# GRAFF 2

## next level **GRAFFITI** techniques

**SCAPE** MARTINEZ

**IMPACT**
CINCINNATI, OHIO
www.impact-books.com

# CONTENTS

## PART 1
## DEEPER ELEMENTS
## OF GRAFFITI STYLE   13

Tags and Statements • Letter Manipulation •
Shades and Shadows • Glows • Glows Demo •
Characters and Objects • Robot Character Demo
• Abstract Character Demo • Color Squares •
Arrow Compositions • Backgrounds

## PART 2
## NEXT LEVEL
## OF STYLES   37

Be the Abstract Original • Lyricals • Computer
Rock • Mechanicals Morphing Demo • Mechani-
cals Visualization Demo • Radicals Demo • 3-D
Wildstyle • 3-D Wildstyle Demo • Double Vision

## PART 3
## FROM SKETCH
## TO PIECE   55

Can Control • Cutting Demo • Shines and Star-
Like Patterns Demo • Burst Patterns Demo •
Flares Demo • 3-D Wildstyle Demo • Abstract
and Realism Demo • Supreme Wildstyle Demo •
Double Vision Demo • Wildstyle Burner Demo

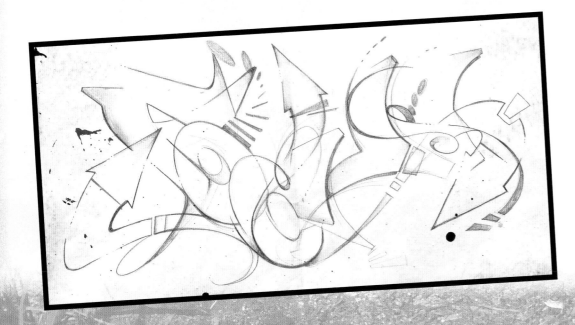

## DEDICATIONS

I would like to dedicate this book to my parents, Jose Martinez and Luz Martinez. I learned over time, the value of my thoughts, and the value of my work, by listening to your wisdom.

Also, to four shining minds—Diamond Hawkins, Destin Hawkins, Fabian Pantoja and Drianne Pantoja. You are all so gifted and talented. Keep your mind on your dreams, reach for the stars and don't let go.

## WHAT YOU NEED

**SURFACE**
Acid-free art paper

**COLORED PENCILS**
Prismacolor (assorted colors)

**MARKERS**
Water-based (assorted colors)

Prismacolor (assorted colors)

Sharpie (black)

**PALETTE**
Spray paint cans (assorted colors)

**OTHER**
Eraser

Latex gloves

Mask

Pencils (light and heavy)

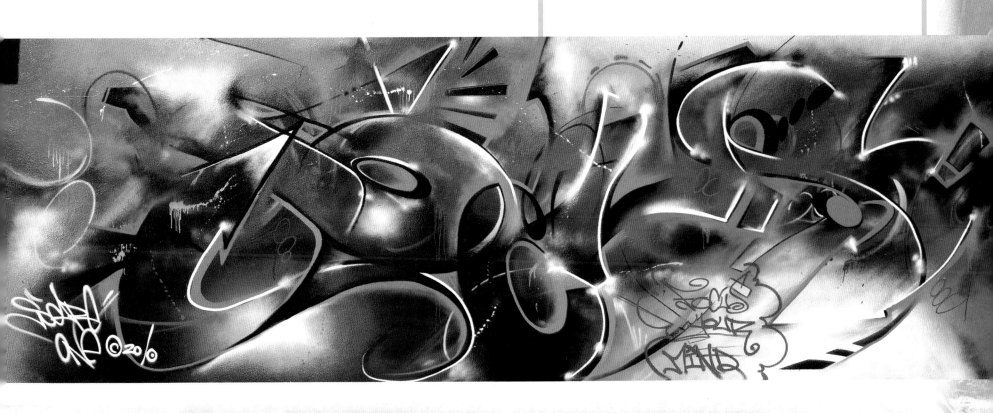

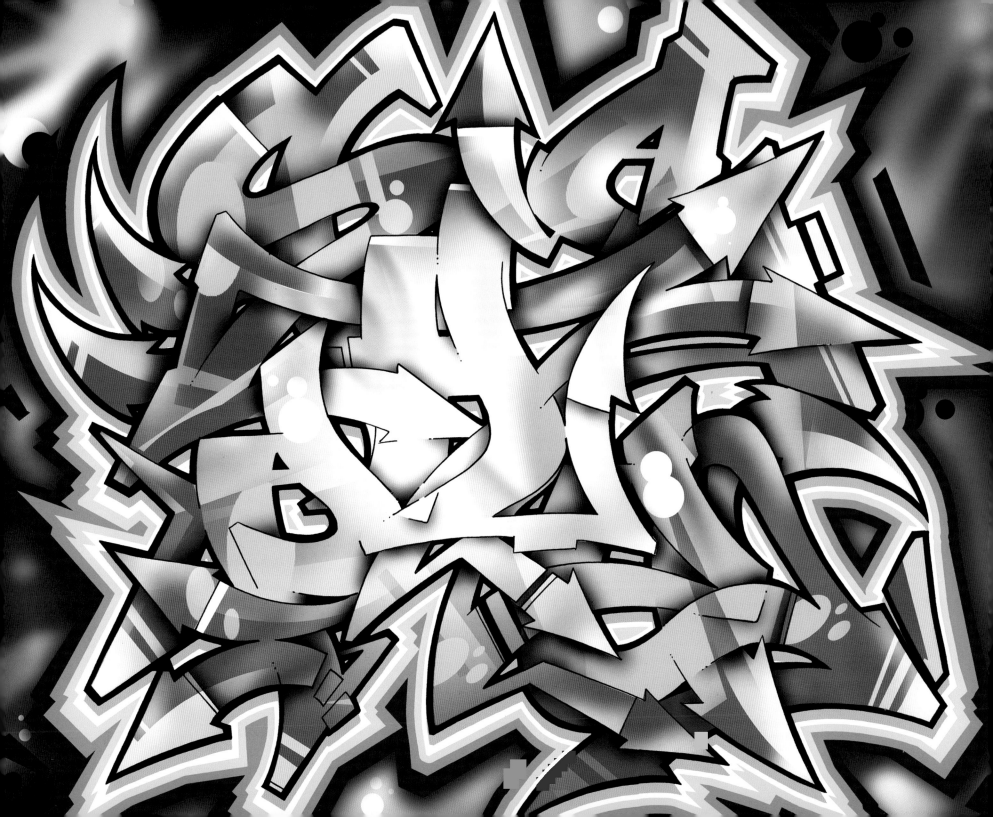

When I was a kid, sometimes I would look straight into the sun. Yes, I know that wasn't the smartest thing to do, but I did it anyway. I tilted my face to the sky, and in a test of wills, it was Me vs. The Sun. So, with my retinas on fire, I danced my eyes around the edges of the sun, trying to see what I shouldn't. I didn't really *see* the sun so much as I *felt* the sun. I felt its warmth on my face and my skin, and received this sort of affirmation. I breathed deeply and thought, "I am HERE."

That same idea fuels graffiti art. *I am here*. That is the rock, the foundation for the movement, the crews, and individual practitioners. It is that passion to experience all of life's ups and downs and share those experiences with the world through your own unique prism. That is the soul of graffiti art.

In this modern era, we risk losing our individuality for the sake of being in our anonymous technological bubbles. We use the latest tech tools to connect, yet we are becoming increasingly distant in our humanity. But graffiti artists never lose sight of who we are. We can't, because graffiti art is a call-and-response culture. It was the first blog, the first social network, high tech with no tech.

Graffiti is an art form about people. It's about sharing, communicating. It's a democratic process. Graffiti is not confined to a box, and you are not charged a fee to be a part of it. The conversation goes on and on, day and night. There are no stuffy security guards telling you "Don't touch!" Graffiti encourages you to touch, to participate. When I do a piece, it is an invitation for you to do an even better one. It is an open invitation to communicate.

Graffiti art is a voice for ordinary people to make extraordinary statements, whether for social emancipation, political change, or simply changing the attitudes of passersby. Your interest in graffiti shows that you are a part of a movement with the power to change the world — piece by piece, tag by tag, ink splatter by ink splatter. And with that end result, how can anyone question that it isn't art?

I believe that if you can dream it, you can visualize it. And if you can visualize it, you can acknowledge it. Once you acknowledge it, you can act on it. And once you act on it, you give it life. In the pages of this book, you'll find the nuts and bolts of graffiti styles, and secrets on how to elevate those styles and bring them to life. I'll show you the tools and point the way, but you must do the heavy lifting yourself. So sharpen your pencils and get your inks in order. Line up your spray cans and get ready, because it's time to roll!

These days I don't look straight at the sun anymore, but I do think of the warmth it gives and remember the validation I received from its radiance. We all have that radiance, that shine inside ourselves. It's called creativity. Look for yours. Tap into it, refine it and use it.

I hope that the ideas in this book will help you get in touch with your creative side and encourage you to grow and push yourself to the next level of your own artistic expression. Let your creative juices flow from your heart, through your veins and into your graffiti artwork. And let that translate into your life. Find your creative voice, and when you do, get out of your own way and let it soar. Put it out there for the world to see, because you are HERE!

# WHAT IS GRAFFITI?

There is nothing on earth so curious for beauty, or so absorbent of it, as a soul. For that reason, few mortal souls withstand the leadership of a soul which gives to them beauty.
— Maeterlinck

Free downloads when you sign up for our newsletter at **IMPACT-books.com**.

5

# SUPPLIES: WORKING ON PAPER

Graff writers work on paper for two reasons: First, as an exercise, since the sketchbook is a holding place for ideas, a place to experiment, jot down notes and save ideas; and second, to save final concepts on good paper, such as a heavyweight watercolor paper, after your ideas have been fleshed out.

You need very little to get started. You want a blackbook, 8½" × 11" (22cm × 28cm) or larger, and a trusty set of pencils and permanent markers of various widths. Keep everything in a backpack. You will always be sketching and doodling, so you want your tools to be accessible and quick to use. Below are some other things to keep in mind.

## Pencils
A softer pencil gives you a darker value; a harder pencil gives you a crisper line. Also, look into charcoal and graphite. Both provide rich and intense blacks, but are easy to smudge. Explore colored pencils too, keeping in mind that they tend not to blend well. Choose what works for you.

## Pencil Sharpeners
I stay away from expensive electric pencil sharpeners. I prefer a sturdy metal, inexpensive sharpener—the handheld kind. Buy them by the bunch, with various opening sizes, and they will last forever.

## Erasers
You can use two types: vinyl and kneaded. Vinyl erasers can be cut and shaped into chisels for erasing in a detailed fashion. Kneaded erasers can be formed into organic shapes to lighten and erase sections.

## Blending Tools
My favorite blending tool is my finger, but it's messy and can leave fingerprints all over your drawings. You can find blending stumps at most art stores. These are tightly wound rolls of paper with a point on each end. You can also use fabric, paper towels or even makeup sponges for excellent results.

## Blackbook
Blackbooks (also called drawing books or plain sketchbooks) traditionally are hardcover and black. The cover protects your drawings and makes it easier to draw outside. Make sure that the paper is acid-free so it doesn't deteriorate. And make sure it fits in your backpack.

## Paper
Art paper comes in many sizes, colors and textures. Get a few different types and experiment. Smooth paper works better with fast-drying inks; paper with a slight tooth (essentially, texture) works well with pencil shading as it holds the graphite. Again, make sure that the paper is acid-free. Try working on larger sized paper as well.

## Markers
Watercolor markers are basic markers that you can find almost everywhere. Usually sold in sets, they are inexpensive and great to use. The drawback is they are water-soluble, and even when dry, they can smear when exposed to moisture. Permanent ink pens are the classic Sharpie or Magic Marker. The color choices are limited, but they're great for practicing tags and outlining artwork, and they work well with watercolor markers since they don't smudge. Paint pens contain actual paint. Some even have a little marble inside to shake the paint up. They're great to work with, but they have a heavy odor and can be messy. Mops are oversized markers filled over capacity with ink, with tips up to 4 inches (10cm) wide. They're often handmade and are designed to drip.

## Inks
You can buy inks in little jars in a variety of colors. Work with them using either a paintbrush or a quill pen. It adds another dimension to your work when you can add a wash or drips from India ink. Check with your local art store for suggestions.

## Watercolor Paints
In conjunction with inks, I like to use concentrated watercolors that are fluid. Check with your art store. Watercolors are transparent. I use them for backgrounds and letter fills.

## Paintbrushes
Choose soft brushes. These let your watercolors or inks flow onto the paper and you don't have to fight with the paint. Again, check with your local art store, where you can pick them up inexpensively (it's good to have a few). Buy various flats to lay down watercolor washes, and a few rounds to add details.

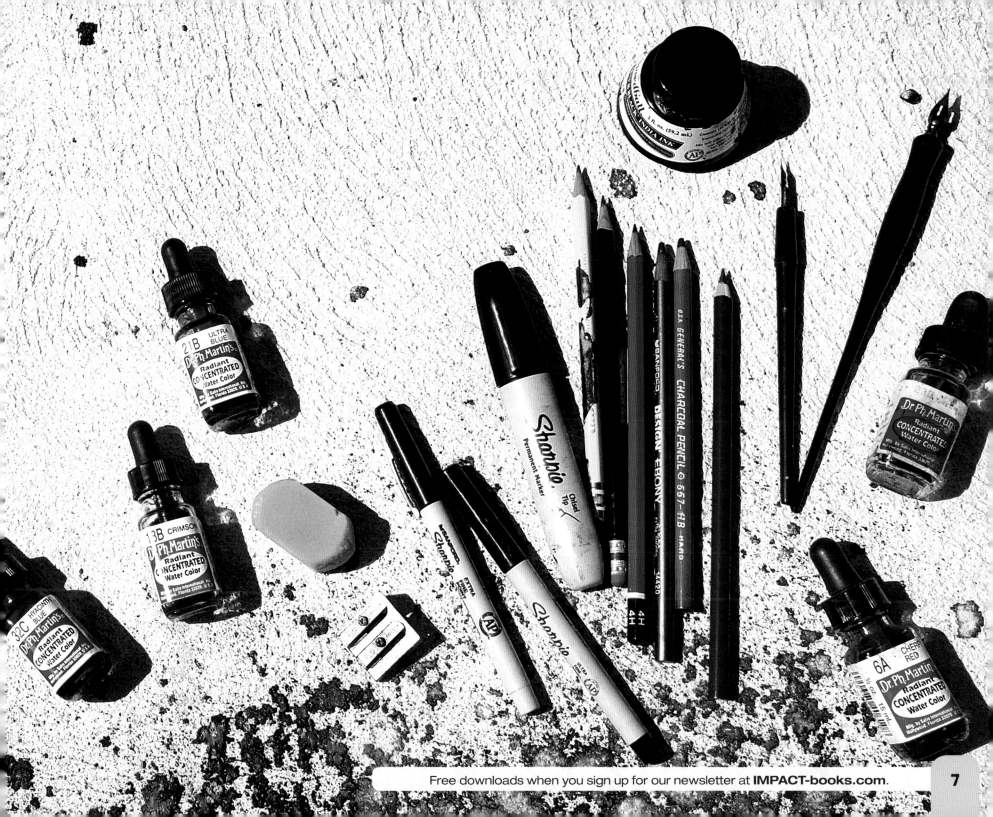

Free downloads when you sign up for our newsletter at **IMPACT-books.com**.

7

When choosing supplies, always go with the best quality you can get. Don't settle for less, or you'll regret it later.

## Spray Paint

The equivalent of the artist's ink or paint, spray paint is the graff artist's most important tool. Not all spray paint is the same, there is a difference between glossy, satin, and matte-finish spray paints. Different parts of the world manufacture paints to different standards, so experiment with as many different types as possible to be sure you make a good choice. Choose a paint that's bold, has a lot of color, sticks well to surfaces and covers surfaces well. Remember, the spray can is connected to the hand, and the hand is connected to the artist's heart, so I cannot overstress the importance of the quality of your paint. You will learn to express everything through the tip of the spray can.

## Spray Can Tips

These are the equivalent of the artist's brushes. There are tons of caps out there, varying among the different types of paint. To start off with, be aware of four basic types with some variations depending on where you are and what's available.

- fat caps
- skinny caps
- outline caps
- fill-in caps

Practice with these for sharpness, evenness, resiliency and calligraphic style. Pack plenty of caps—more than you need (and take care of them.)

## Latex Gloves

Gloves protect the skin from paint. As you work your piece and change spray can tips, paint will begin to accumulate on your fingertips and hands. This can be problematic as it turns into a gooey mess, sometimes clogging tips and getting in the way. Also, depending on the type of paint, too much paint on exposed skin can be harmful down the road. It is best to play it safe. Bring a box of medical latex gloves and change them often.

## Mask

To prevent inhaling fumes, use a legitimate gas mask—do not use a bandanna or dust mask! It may take a bit to get used to working with one, but it will protect you from fumes and overspray getting into your nose and mouth. Many a writer can talk poetically about how they never used masks back in the day. And many a writer can say they wish they would have. Play safe, play longer.

## Health Tips

When executing your work, use common sense. Follow any instructions to the detail on anything you use. Do not leave your spray paint in direct sunlight. Do not leave your spray paint in any area close to extreme heat or fire, heaters, etc. Take frequent breaks to rest your eyes, walk away, remove the gas mask and look at your work. Take a few deep breaths and continue your journey.

## Discarding Materials

Do not leave anything at the site. If you must, bring extra bags to collect residuals: used latex gloves, broken or used spray can tips and, most importantly, empty spray cans. Even when you think they are empty, they are not. Over time, the paint will settle and someone will walk by, pick it up, and maybe choose to destroy your piece. Take everything you brought with you and dispose of all your used materials properly. From prep to completion, leave nothing. Leave the space better than you found it, your art included.

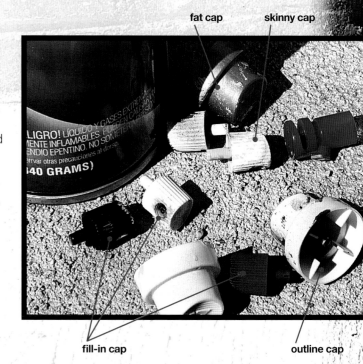

fat cap     skinny cap

fill-in cap     outline cap

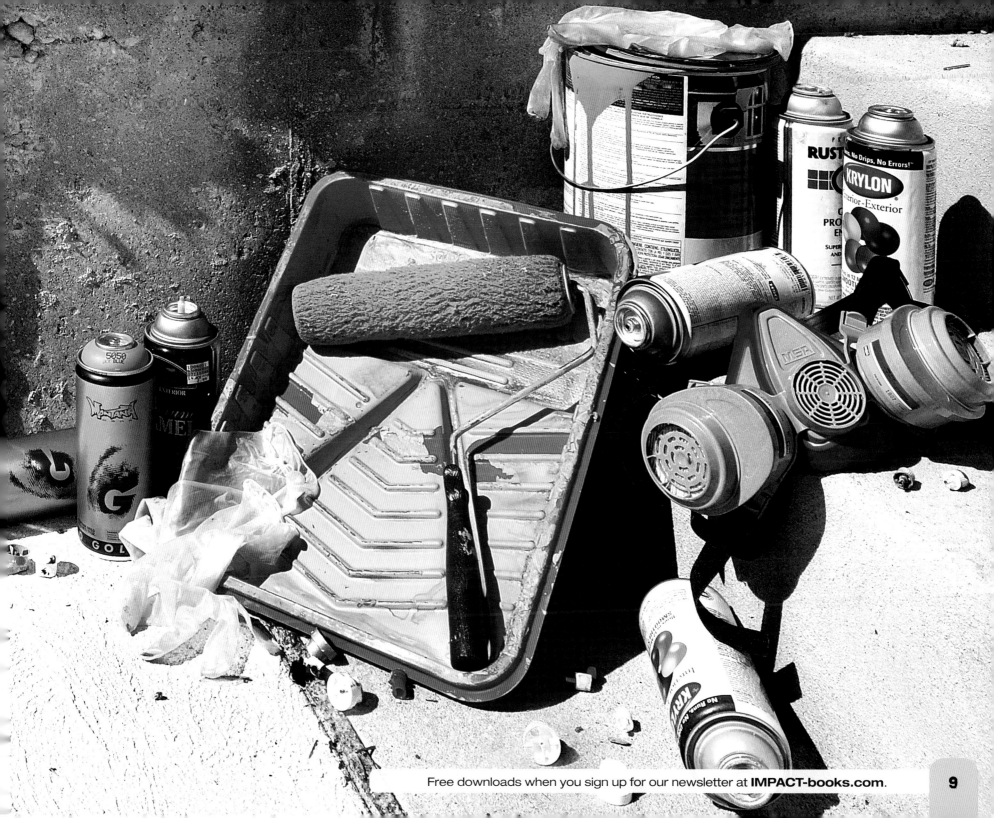

# APPLYING COLOR

A graffiti artist's approach to color is a bit different from that of a classically trained artist. You will notice that in the following pages, if you haven't already. My theory about color is that it shows the connection between the art and you. For me color is everything, a whole universe to explore, even when it's black and white. In the end color becomes your signature. It becomes your style, and that is what we are here for. So let's explore some color styles!

## Choose Colors That Work Together
The idea is to continue to develop your color senses. Notice how the yellow over blue makes the letters seem to vibrate off each other and right off the wall.

## Black on White
This traditional approach works with ink on paper, paint on canvas or paint on a wall. In graffiti art black and white are colors just like blue or red. Stretch yourself creatively to use them in your compositions.

## White on Black
This stark change challenges your perception on how to create your artwork and raises creative questions. How will you add shine to the letter since it's already outlined in white? What kind of fill-ins can you use?

## Rotate Color Temperature
These three colors bounce off each other with the temperature rotating out from the warm orange in the background to the cool blue of the outline back to warm with the pink fill-in.

Get bonus material at **http://Graff2.impact-books.com**.

## Take Your Schemes a Step Further

Now we'll take things to the next level and explore how to apply various color elements in 3-D form. We will work with a basic cube so that you can focus solely on the colors, and not be distracted by the form itself. Focus on the colors and the way they interact and function within the confines of the outline.

## Start With the Basics

Look at the black and the basic shape. This is a simple outline, but you can use color to bring it to life in a variety of ways.

## The CMYK Model

Cyan, magenta, yellow and key (black). In our case it's blue, yellow, hot pink and black. This color model is used for printing purposes, but using those colors in graffiti produces some great art, too.

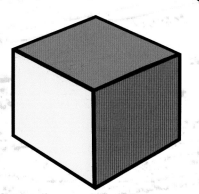

## Vary Shades to Add Depth

The same shape is filled in with red using two darker shades for the left and right areas. Using various shades of the same color will add depth to your forms.

## Add a Face for 3-D

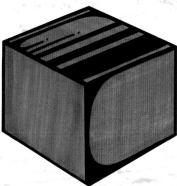

We have the same box shape as before, but have put a blue face on it. Some 3-D graphics are added on the other two sides in black. Now you've gone from a flat shape to adding depth and dimension, all by using color.

## Dots, Slices and Fill-Ins Help 3-D Effects

Going a step further, give the cube a yellow face and do a fill-in. Add dots, some green slices and even some drips for effect. The 3-D is done in purple, tying all of the elements into place.

## Work Multiple Planes

Here the face is on top. Add a turquoise strip on the top and run it down the right side. When working colors from one plane to the next, keep some 3-D references in the letter form so the viewer does not get lost in the composition.

Free downloads when you sign up for our newsletter at **IMPACT-books.com**.

11

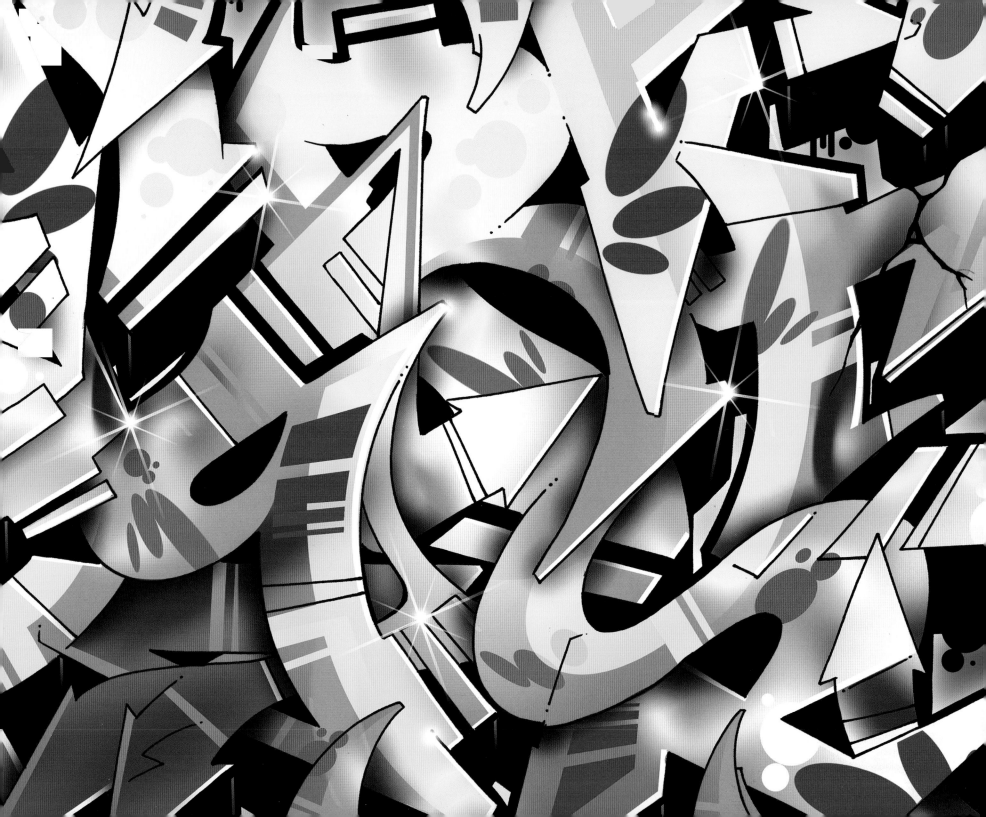

# DEEPER ELEMENTS OF GRAFFITI STYLE: EXPLORE YOUR MARKS

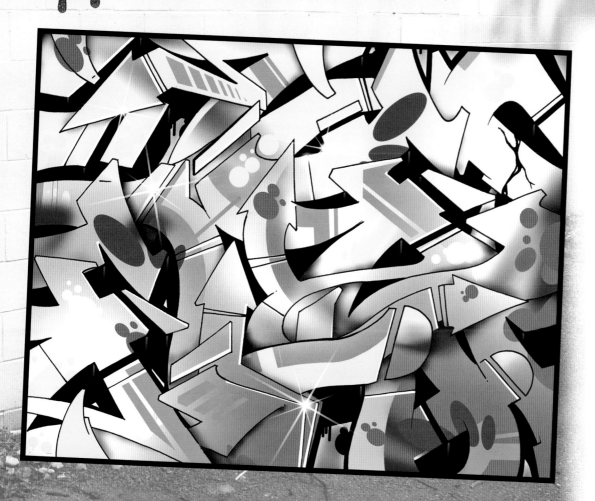

You leave your mark to let people know you were there. It has been this way since the beginning of time. It's that timeless quest to share with the world where you were and where you are going.

In the journey of graffiti art, it all starts and ends with the written word and creating the dope styles of those written words. Keep your mind open and accept new ideas of calligraphy. Your style will change over the years. What you hold to be true today will fade away, and a new truth will take its place. Keep pushing for the new.

When people think of graffiti art, it is often the tag they think of first. The tag is the artist's identifying mark. It is the artist's signature. Whether painted or marked, in private or in public, it deserves your stylistic energy.

As an artist working in the tag space, you will understand nuances that most casual fans may not notice—like form and spacing of your letters, and the differences between quotes and sentences. It's all about style, and having a good tag style is a great jumping-off point. Now let's explore some ideas!

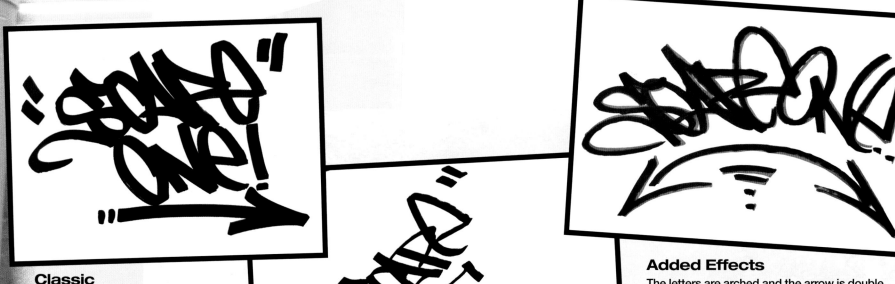

### Classic
This is the basic statement.

### Angular
The tag is written at a sharp 45-degree angle with the letters starting small and exploding in size as they move upward.

### Added Effects
The letters are arched and the arrow is double pointed like a frown. The initial tag was done in black ink, then gone over with an orange paint pen. Yes, you can add effects to your tags!

## Your Style Is Your Substance

There are many different elements that can affect your style, from added effects to the tools you use and surfaces you work on. You'll need to dig into the materials of the trade, learning their strengths and their weaknesses. All of these elements compose another level of your expression.

## Mops

Homemade markers are filled over capacity with ink.

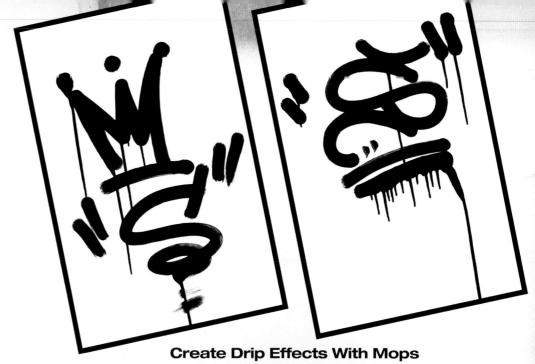

## Create Drip Effects With Mops

Mops are designed to drip. They're great for hardcore writing styles and are not made to be subtle.

## GET JUICY

When doing your tag, make sure that your marker is juicy, meaning filled to capacity with ink. This will help prevent streaks in your work. Apply the proper amount of pressure to get the right balance of opaqueness without drips. If you go too fast without enough pressure, you will have streaks and blurs. But too much pressure and slow movement will leave you with a drippy mess. Keep experimenting until you get the effect you want.

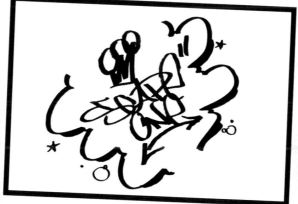
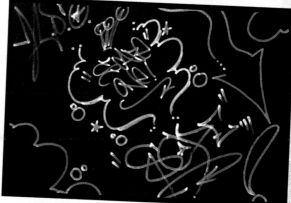

## Surface Affects Style

Even something as simple as the surface you work on can affect your style. The tag cloud on the left was done in simple black ink on a white surface. The tag cloud on the right used white paint pen on a black surface.

Free downloads when you sign up for our newsletter at **IMPACT-books.com**.

15

## Tag Clouds

Tag clouds are cloud-like lines surrounding tags. They give added effect and a sense of depth to make the tag stand out. Tag clouds can help introduce more expressive lines and symbols into tags. They are not only a cool way to capture your signature, but also a great way to add a quote or statement to your work.

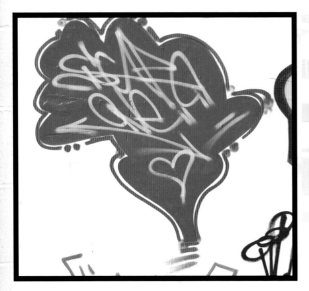

### Add a Solid Back

This tag cloud is created as a series of overlapping bubbles. A broken outline is added in orange, and then the yellow tag is dropped in to finish it off.

When creating your cloud, be sure it's the correct shape, and that you have enough space for the tag.

### Drop Shadows Add Depth

This tag cloud is executed in red on a white background. The drop shadow is added behind it in black.

### Elevated Style

This style is shaped less like a cloud and more like a wrap. It is outlined in black with a burgundy drop shadow. Keep in mind that you can change the line weight as you outline the cloud.

## Build Your Statement

There is a clear difference between doing a tag and making a statement. The tag is your signature, and you can take liberties with it. When creating a statement, it should be legible to a degree—you want the masses to read your message and understand the intent. What is it you want to say, and who is going to be your target audience? Is it other graff writers, or members of your crew, or the outside world? Your intended audience will dictate how much style you want to add to your statements.

### Linear Pattern
There are three levels involved in this pattern, each one a little more complex than the previous.

### Style Impacts Your Message
The spacing between your letters and words will influence how legible the statement is and how it looks to the outside world.

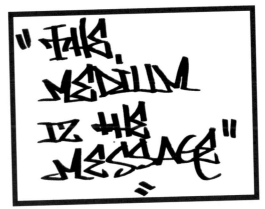

### Roll Call Pattern
The words are stacked in a list-like pattern, so the message reads vertically rather than horizontally.

Free downloads when you sign up for our newsletter at **IMPACT-books.com**.

17

# LETTER MANIPULATIO

Letter manipulation is a cornerstone of graffiti art. Experiment with skewing, distorting and warping your letters, and you'll discover ways to infuse your creative influence into your letter development.

Don't be afraid to take creative risks—the more you practice, the more intuitive and effortless manipulating letters will become for you.

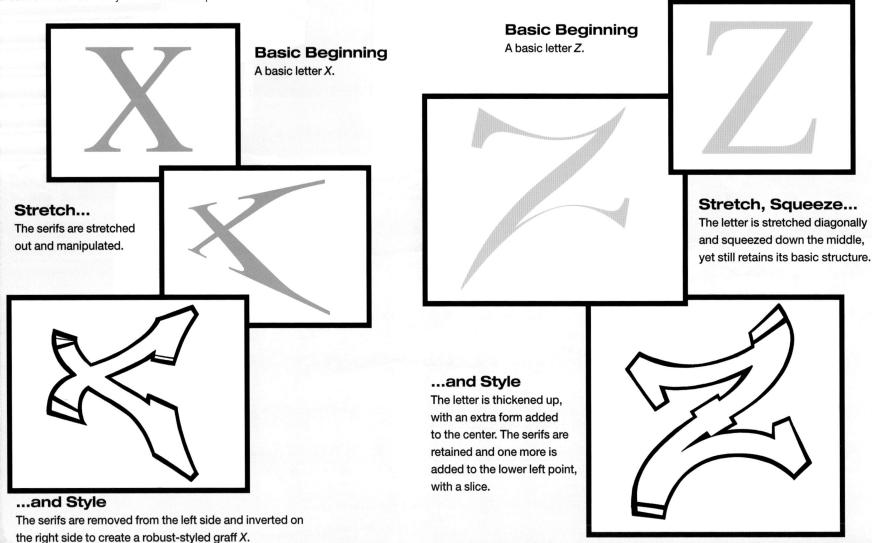

### Basic Beginning
A basic letter *X*.

### Stretch...
The serifs are stretched out and manipulated.

### ...and Style
The serifs are removed from the left side and inverted on the right side to create a robust-styled graff *X*.

### Basic Beginning
A basic letter *Z*.

### Stretch, Squeeze...
The letter is stretched diagonally and squeezed down the middle, yet still retains its basic structure.

### ...and Style
The letter is thickened up, with an extra form added to the center. The serifs are retained and one more is added to the lower left point, with a slice.

## Word Manipulation

The same process for manipulating single letters can be applied to whole words as well. The possibilities are limitless.

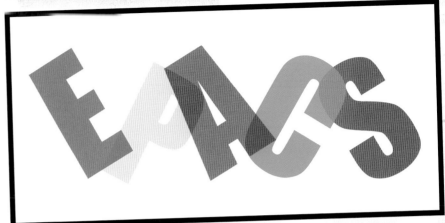

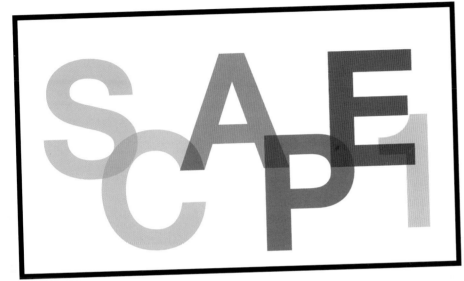

### Backwards Tilt

The letters in *SCAPE* are arranged backwards and tilted at opposite angles to give a sense of rhythm. The valleys between the letters can now be easily filled in with connections and extensions.

### Zig-Zag

The letters in *SCAPE1* are strung along from left to right, and arranged in a zig-zag pattern, with each alternating between being dropped down or raised up. This is a great method for working with artwork that has to be confined to a tight space.

### Backwards Wave

The same letters are formed into a wave-like pattern. Bent and curled serifs are added, which could be taken to another level by bending and curling them back into the letters.

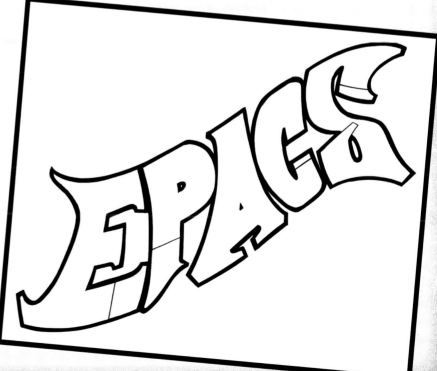

Free downloads when you sign up for our newsletter at **IMPACT-books.com**.

19

Shading and shadows define objects visually.

When drawing or painting shadows, the most important thing to keep in mind is light. Imagine a lamp shining at a 45-degree angle towards one side of your piece. That light will cast shadows all along your letters. Be aware of the direction the light is coming from. If your light source comes from the right, all your shines need to be on the right and your shadows should drop to the left. If your light source is directly above, then your shines can wrap all around the letters, and your shadows will drop straight down.

It may seem complicated at first, but it doesn't need to be. Think of your letters less as calligraphy and more as forms, shapes and objects. Once you begin to do this, you can open the door to shading and shadows and bring your work to life.

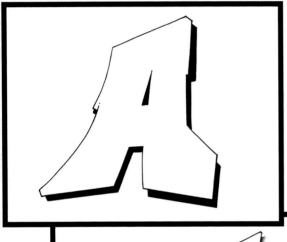

### Drop and Shift
This standard drop shadow is opaque and traces the shape of the letter. Basically it takes a layer of the letter, drops it down and shifts it to the right.

### Fade and Float
This take on the drop shadow style is especially effective when your letters overlap. It is the basic drop shadow, but the exterior edges are faded out so that it appears to float and is softer on the eyes.

## EXPLORE FORM AND COLOR

Once you learn how to work your shadows with black, you can then get more creative and cast shadows with other colors. So if you outline your piece in white, try casting your shadows in white.

What works for shading and shadowing your letters will work for your characters and objects as well. Try adding a basic drop shadow on a symbol or a favorite character and see how it looks.

Continue to explore and practice, and soon you will develop your own unique graffiti shading techniques!

## Solid 3-D

The three basic block shapes of the letter are outlined in black. There are no gradients to the shading—it's solid all the way through. The shadows are done in curves and arcs. The portion of the forms that lack light are rendered all in black, and the forms that over-lap have the inked curves.

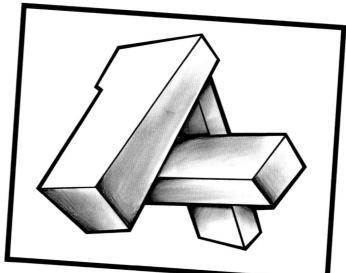

## Gradient 3-D

This approach uses gradient values with the 3-D effect. The light source exposes where the face of the letter could be. The shadows range from dark, where there is no light, to lighter, where the shapes are exposed.

## Casting Shadow

The letter *A* is basically a triangle shape, so the shadow that gets cast must also be in that same basic shape. The gradient is dark closer to the letter and lighter towards the end, fading at the edges.

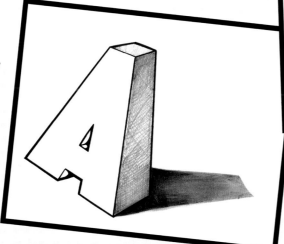

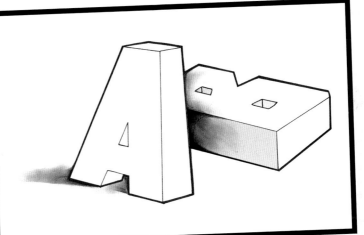

## Multiple Light Sources

With multiple light sources you can place letters in front of or behind each other. The *A* is a triangle shape, so the shadow is cast similarly. The other light source casts the shadow behind the *A* onto the *B*, so the shadow on the *B* doesn't need to reflect the true shape of the *A*.

Free downloads when you sign up for our newsletter at **IMPACT-books.com**.

21

# GLOWS

Sometimes called a *stroke* or a *force field*, a glow is a solid band of color that wraps around your letters, characters or objects. It is meant to add life to your work and make it pop.

Glows can make your forms seem to shine or even glow in the dark. They should be done with colors that contrast or complement the color scheme of the form they are being wrapped around.

Your glows should start as basic strokes or solid lines, but can grow from there. They can be broken up, stretched, and become a lot more intricate, adding greatly to your graffiti compositions.

## Basic Glow

A basic glow is added to the letter *A*. The magenta band of color is the glow. Here it is rendered in a basic fashion, but you can change the line weight as you wrap the color around the letter.

## Double Glow

This letter *E* has a double glow. The band of yellow is your basic stroke, and the green is the second stroke. Breaking up the green band into dots at random points added some flair.

## Slice and Shift Double Glow

A double glow of purple and blue surrounds the *O*. On the top of the letter a filament of the light blue is sliced off and shifted to the right. On the lower portions you see how easily glows lend themselves to clouds and dot patterns.

## Paint Drops and Double Up

This *I* has a bit more style to it. The glow is light blue, and the line weight changes as it goes around the letter. Paint drops shoot off to the right, and the glow doubles up on top where the oval sits.

## Deeper Elements

# MAKE YOUR LETTERS GLOW

## MATERIALS

**SURFACE**
Acid-free art paper

**MARKERS**
Black Sharpie, Copic, Prismacolor

**OTHER**
Eraser
Pencil

Glows are not solely the property of letters, characters and objects—they can also be used on your tags. In many cases it is wise to use shades of the same color for your glows, i.e., a dark blue followed by a light blue.
   Follow the steps to create tag glows.

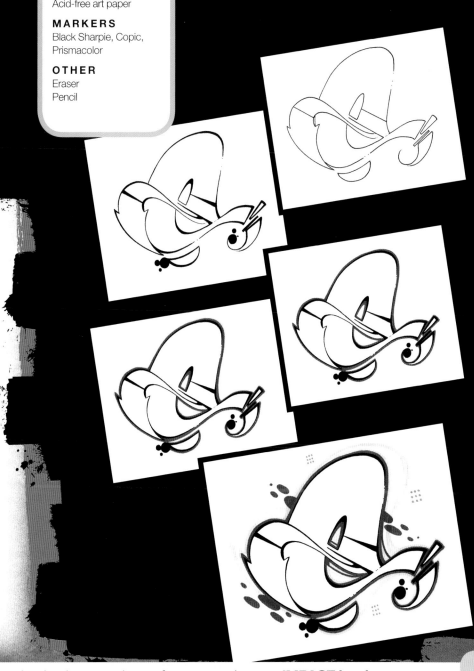

### 1 Sketch the Letter
Sketch a lowercase *e*. The outline is not solid. It is broken up here and there in a very loose and lyrical style, but yours doesn't have to be.

### 2 Modify the Outline and Line Weight
Darken the outline and change the weight of the line as you work around the letter. Keep your line thin where the outline breaks and thicker where it's solid. Add some black dots in a few random places.

### 3 Add the First Stroke
Drop in a magenta stroke. With this stroke, completely outline the letter, closing the gaps from the broken-up outline. Don't stroke the dots.

### 4 Add the Second Stroke
Go with a color that will pop off the page. In this case, go with a bright yellow for the second stroke. Wrap the letter with the yellow. Add some flair to it—drop a band of yellow into that empty space in the center of the letter.

### 5 Add Finishing Touches
Add flairs and ribbons of color around the letter with yellow. Accentuate the letter's movements. So if the letter is leaning and flexing to the right, then your added strokes need to emphasize that. Add some extra flair with the magenta, making sure the dots are in the same pattern and direction.
   Try it again and add your own twists to it.

Free downloads when you sign up for our newsletter at **IMPACT-books.com**.

23

Traditionally, characters and objects have been used in graffiti as forms of decoration off to the side. But you can make your piece more memorable by integrating characters and objects into it. For example, let an object replace a letter in your piece, or imbed a character into your letters, allowing it to flow along with the words and letterforms.

Your choice of characters and objects, as well as the way you execute them, will tell a story. Let's look at some ways you can use them successfully in your pieces.

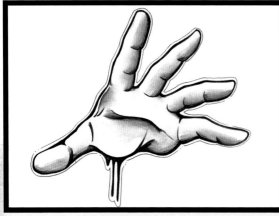

### Hands to Serve You

You can use clenched fists, open hands, or a variation of both. The key is how you use them. The hand is used as a tool to serve. So ask yourself how the hand can best be used to serve your message to the public.

## BE AWARE OF THE MESSAGE YOU'RE SENDING!

When adopting any well-known characters or objects, be sure to research their exact meaning and social connotations, if any.

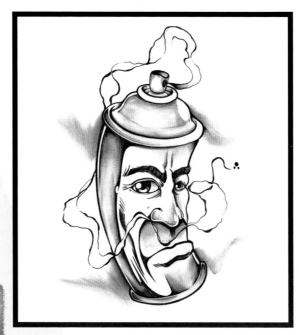

### Modify Your Objects

Adding a touch of humanity to objects can help the viewer more easily relate to them. This paint can actually has three elements: the can itself, the face and the flow of the paint coming from the tip. All these elements can be tweaked to communicate the message you want to send.

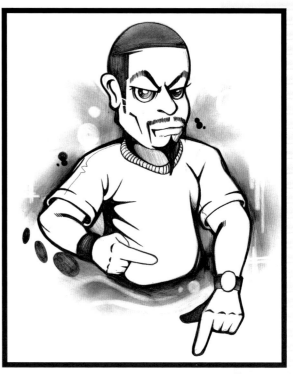

### Add Parody

Keep elements of parody in mind when creating characters. You can take creative license with your work; it doesn't have to be hyper realistic.

The cartoon character seen here carries a lot of stylizations such as oversized eyes, a larger-than-average head, and super-sharp facial hair, that have been worked into the total composition.

## Elevate Your Style With Integration

The visual impact of characters and objects can't be fully gauged until they are paired with letters. This can be done with color patterns, by imbedding them into letters, and by transforming one into the other.

## Letters Into Characters

Characters can replace letters, but bits, pieces, slices, and other forms can also be imbedded into compositions. This piece reads "Believe." Both of the characters' heads are actually sections of the letter *E*. They are imbedded into the letterforms and the hands are connected to sections of the letters as well. This takes the wildstyle to a whole other level.

## Characters Into Letters

This piece reads "Style." Elements of the Transformer-styled character are brought into the rest of the letters. The features and textures of the robot and its metallic surface permeate the piece, adding a level of complexity that otherwise might not have been achieved.

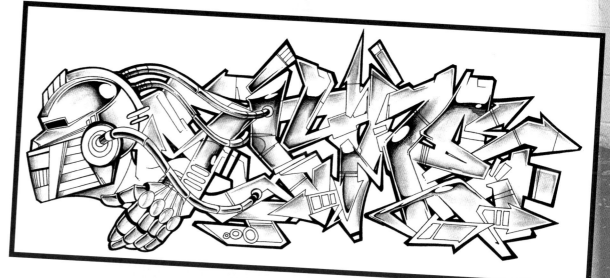

Free downloads when you sign up for our newsletter at **IMPACT-books.com**.

25

# CREATE A ROBOT CHARACTER

## MATERIALS

**SURFACE**
Acid-free art paper

**MARKERS**
Black permanent

Blue, gray, red and yellow water-based

**OTHER**
Eraser
Pencils (light and heavy)

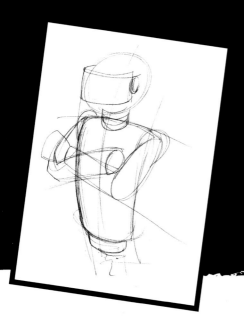

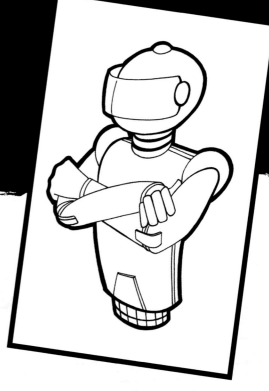

## 1 Sketch the Piece

Using a light pencil, do a rough sketch of the basic shapes. A robot can be broken up into cylinders, tubes and spheres. Break up your robot into its most basic shapes. Be as free, open and loose as possible. Use the simple, balanced lines as the skeleton for your shapes.

## 2 Flesh Out the Robot

Go over the initial sketch with a heavier-leaded pencil. Keep the basic lines and shapes that you want, and erase the line strokes outside the character. Don't worry about anything else at this step besides fleshing out your character.

## 3 Ink the Outline

With a black permanent marker, go over the lines from step 2, remembering to change the line weight as you go over the pencil lines. Keep the lines thick towards the edges and thinner as you go into the robot. Add a thick black stroke around the entire character to make it pop. Erase all other pencil lines.

IMPORTANT: Make sure you use a black permanent marker here and not a water-based ink pen as it will bleed later and potentially ruin your artwork.

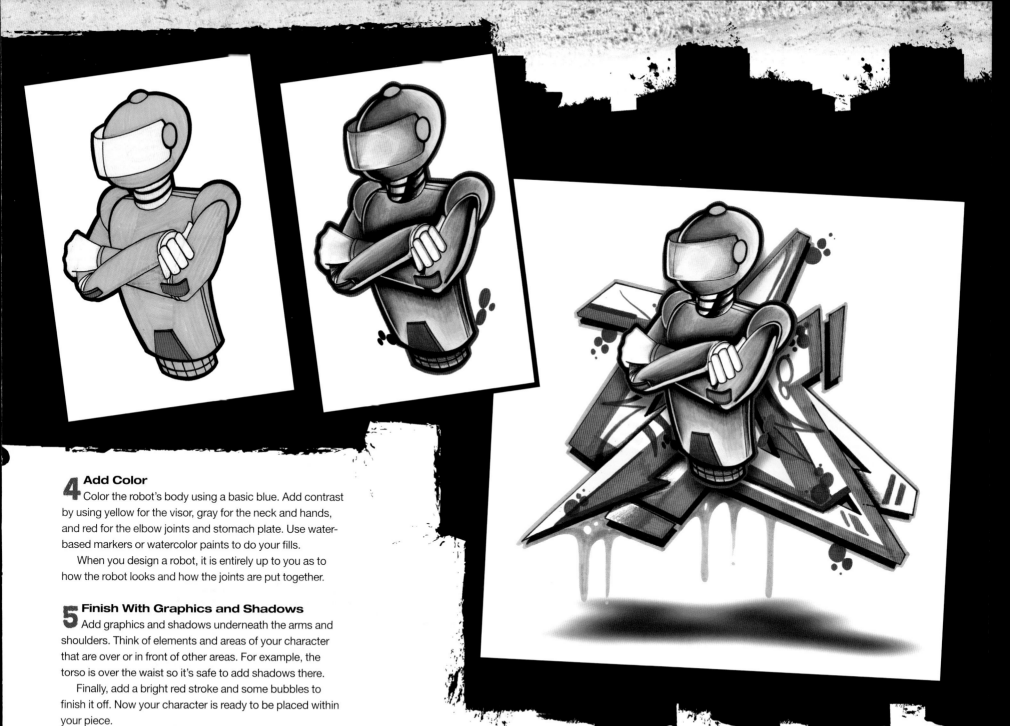

## 4 Add Color

Color the robot's body using a basic blue. Add contrast by using yellow for the visor, gray for the neck and hands, and red for the elbow joints and stomach plate. Use water-based markers or watercolor paints to do your fills.

When you design a robot, it is entirely up to you as to how the robot looks and how the joints are put together.

## 5 Finish With Graphics and Shadows

Add graphics and shadows underneath the arms and shoulders. Think of elements and areas of your character that are over or in front of other areas. For example, the torso is over the waist so it's safe to add shadows there.

Finally, add a bright red stroke and some bubbles to finish it off. Now your character is ready to be placed within your piece.

Deeper Elements

# CREATE AN ABSTRACT CHARACTER

## MATERIALS

**SURFACE**
Acid-free art paper

**MARKERS**
Black Sharpie, Prismacolor

**COLORED PENCILS**
Prismacolor

**OTHER**
Eraser
Pencils (light and heavy)

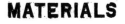

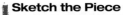

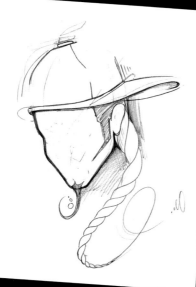

### Sketch the Piece
Sketch the basic oval shape of the face with a light-leaded pencil. Use light pencil strokes and very loose lines. Don't worry about what it looks like at this stage, just let it develop.

### Flesh Out the Character
Do a second sketch, more fully rendered. Add the eyes, nose and mouth. Flesh out the baseball cap and ears. Add a ponytail following the flow of the lines. Be careful not to make the sketch too dark—it should still be fairly light, just slightly darker than in the previous step.

### Erase Into Abstract
This is where your character begins to turn abstract. Erase portions of the head. Study your character and look for where you can omit certain areas that would actually strengthen your composition. Erase the entire face so the character becomes anonymous and adds a sense of mystery to the work.

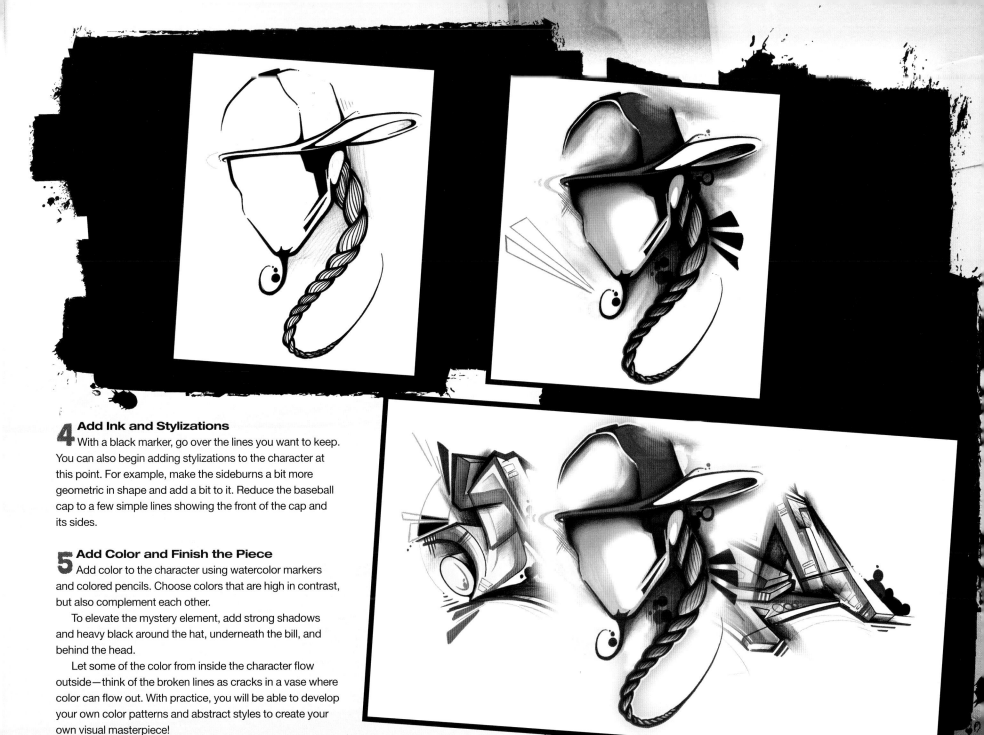

### 4 Add Ink and Stylizations

With a black marker, go over the lines you want to keep. You can also begin adding stylizations to the character at this point. For example, make the sideburns a bit more geometric in shape and add a bit to it. Reduce the baseball cap to a few simple lines showing the front of the cap and its sides.

### 5 Add Color and Finish the Piece

Add color to the character using watercolor markers and colored pencils. Choose colors that are high in contrast, but also complement each other.

To elevate the mystery element, add strong shadows and heavy black around the hat, underneath the bill, and behind the head.

Let some of the color from inside the character flow outside—think of the broken lines as cracks in a vase where color can flow out. With practice, you will be able to develop your own color patterns and abstract styles to create your own visual masterpiece!

Free downloads when you sign up for our newsletter at IMPACT-books.com.

29

# COLOR SQUARES

Color squares, or cut outs, are fields of color in the general shape of a square or rectangle, hence the name. They can help add an extra dimension to your artwork.

Color squares can be used within color squares to develop grid patterns filled in with various themes from your artwork, or even as windows for your character to jump from one space into the next. The possibilities are endless.

When using a color square, keep in mind that the pattern inside it should be different from the color scheme in the main piece. In other words, the narrative should be the same but the colors, technique, or style pattern should be different.

Think of the color square as a means of opening another window into your artwork. It is a unique tool that can be used to take your piece to a whole other level.

### Basic Color Square
This is a basic color square, rendered in pencil. It is filled with random abstract shapes and lines, but the main focus should be the slight gradient effect. The darker value along the edge progressing into a lighter value in the center draws the eye towards the center.

### Bits and Slices
This is a critical creative jump. The color square segues into bits and slices, some shooting right off the top and some coming from behind.

### Layers
Here are two color squares, one layered on top of the other. The square in the foreground is hard edged, while the one in the background has the gradient fill. This is done to differentiate between the two and avoid confusion when working with both.

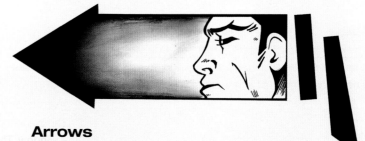

### Arrows
An arrowhead is formed on one end of the rectangle. A character is placed *inside* the space, and the back end is finished with bits.

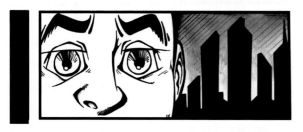

## Characters and Scenes

In another example of the number of variations you can have, a character is placed inside the color square panel and a skyline is added. This could then be placed over a section of letters.

## Doorways

The color square is used as a door with the letter *S* passing through it. The door serves as a place to transform from one style into another. In this case it's a simple color switch.

## Style Elements Incorporated

The color square floats on top of the letters and the character (eye) is inside the panel. Black square bands create parts of the background as well.

## Patterns

The color square is rendered in blue, but is filled in with a pattern that may not be used explicitly for the letters since there is more of a freeform element to it.

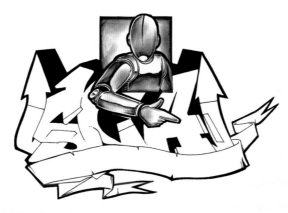

## Windows

The color square has a gradient fill but is also used as a window. This allows the robot character to occupy two dimensions, both inside and outside the window.

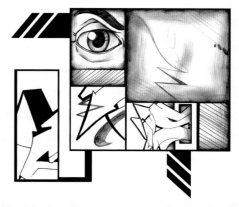

## Collage

All the levels are incorporated together. At this level bits, pieces, and slices of letters and characters create a new composition.

Free downloads when you sign up for our newsletter at **IMPACT-books.com**.

31

# ARROW COMPOSITIONS

In general with graffiti pieces your main focus is on the letters, but when working an arrow composition you do not focus on the letters at all. NO LETTERS!

Just let your imagination and the arrows run wild. Create angles and flows, letting the arrows swirl, curve and bend. The key here is that you will create a composition that does not have any clear basis in letterforms. Only after you are finished can you look at your patterns and begin to see letterforms in the compositions. You will see bits and pieces and sec-tions that could spell out a letter, and that becomes your jumping-off point to create your letters later.

There are four basic types of arrow compositions:

- freeform
- abstract
- flat
- three dimensional

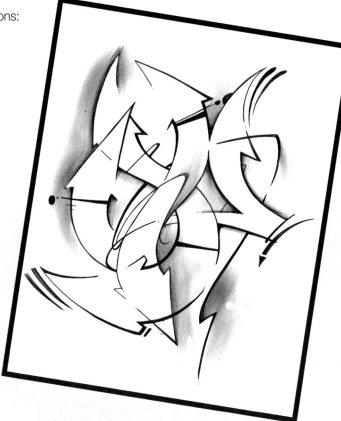

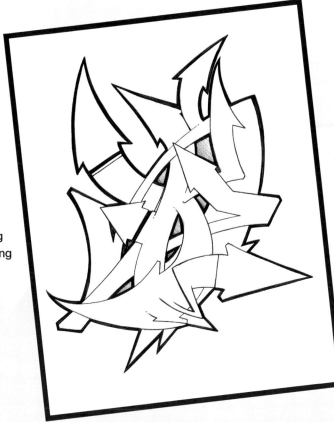

## Freeform
Curved arrows create a free-flowing composition. The focus is on creating balance and symmetry.

## Abstract
Take the previous sketch and work backwards. Deconstruct and break it up into pieces. It is simplified with fewer lines, but the lines that are kept have been added to, so that they're more free-flowing.

Get bonus material at **http://Graff2.impact-books.com**.

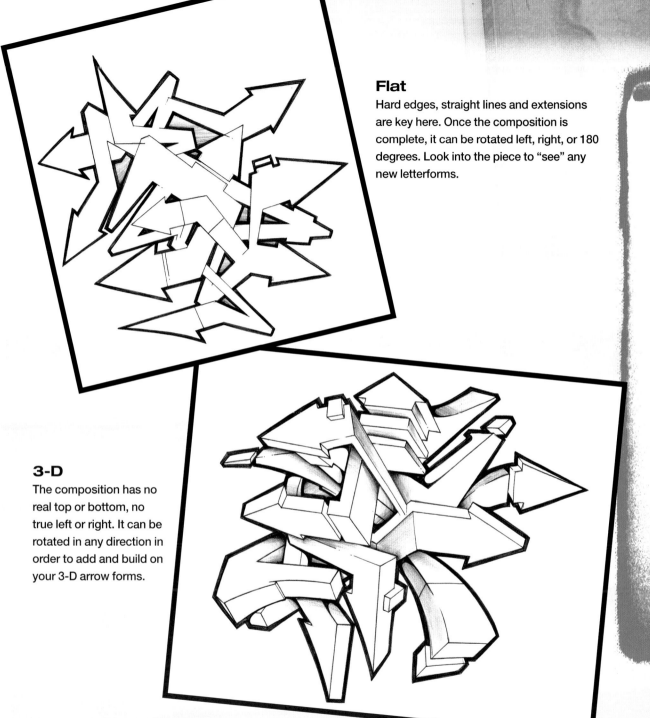

## Flat

Hard edges, straight lines and extensions are key here. Once the composition is complete, it can be rotated left, right, or 180 degrees. Look into the piece to "see" any new letterforms.

## 3-D

The composition has no real top or bottom, no true left or right. It can be rotated in any direction in order to add and build on your 3-D arrow forms.

## BREAKING THE BLOCK

Arrow composition exercises can be especially helpful in times of artist's block. It's a way of stimulating ideas and getting creative juices flowing again. Try this out:

- Open your sketchbook to a blank page. Look at it for a few seconds, but do not think about what you are going to create. Keep your pencils, markers and inks nearby.

- Flip through some of your old sketches. If they are on loose pieces of paper, collect them and lay them out on a table, letting them overlap in random ways, revealing bits and pieces of each sketch.

- On your sheet of paper, draw out an arrow in any specific style. From that arrow, begin to build upon it. Do not think of letters, think only of arrows, connections, overlaps, and extensions.

- Let the creativity flow through you, from your heart to your hands and onto the paper.

Free downloads when you sign up for our newsletter at **IMPACT-books.com**.

33

A good background will make your piece shine and pop. If you think of the letters and characters as being your main dish, then the background is your plate.

There are no hard rules when it comes to backgrounds, but remember that you want to visually connect all the elements of your piece. So don't haphazardly throw colors together in the background with no regard to the rest of the composition. It won't work. Ask yourself what you can do to tie your characters and letters together and finish off the message.

Backgrounds can be very basic, or have more radical styles. They can be scenes, color patterns, clouds, or a combination of all that. There are infinite possibilities—all you need is your imagination!

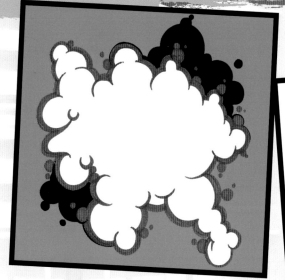

## Elevate Clouds With Twists and Turns

Here a classic white cloud is dropped onto a teal background, then outlined in orange. The thickness of the outline creates a cloud-within-a-cloud effect, and the dots and bubbles give it a floating movement. The black cloud behind it all adds a layered effect.

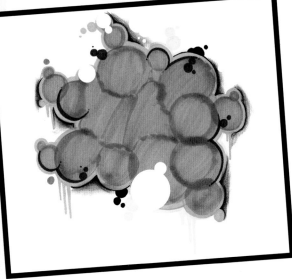

## Reverse Cloud Effect

The white is brought back into the cloud, cutting into the blue to create a reversed effect. Drips, bubbles and highlights are added in dark blue and yellow. Finally, the black clouds and shadows are created for extra dimension.

## Lyrical and Free

This style can be used to represent teardrops or flames, and works especially well for stretching around letters. It is unidirectional with no set top or bottom, but it needs to really work with the shape of the letters or character that it sits behind. The organic shape is constructed of bold bright colors, with thick bold strokes, curves and twists added around it.

## FREE DESKTOP WALLPAPER!

Download free *Graff 2* desktop wallpaper at http://Graff2.impact-books.com.

## Break Up the Space

Here a flat yellow background is laid down, then orange and red bars and stripes are added in a random pattern. Darker shades of burgundy and black are laid in, and triangle shapes are cut out. Dark shadows and white highlights are added to increase the illusion of depth.

## The Sky's the Limit

Skylines are classic ideas for backgrounds, but they can be a bit basic. To step it up a notch, each level of buildings is built up a shade darker than the one underneath it to create a cascading feel, and draw the eyes towards the center.

## Slice and Shift

Squares and rectangles are stretched across the space and tilted at an angle. The various elements are then sliced and shifted to create a geometric effect. To avoid having too much contrast, the colors are kept to similar complementary shades.

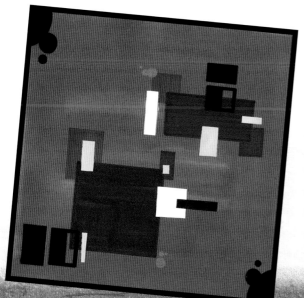

## Layers Add Dimension

Various squares and bits of red, burgundy, yellow, white and black are placed on top of an orange field. Some areas like the yellows sit on top, while the burgundy falls back, creating a layered effect for extra dimension.

## BE FLEXIBLE WITH YOUR WORKING PROCESS

When doing an abstract graffiti piece, you may find that creating the background first works great. For a straight piece, you might want to do the background last. There will also be times when you work on all the elements simultaneously. Find the process that works best for you.

Free downloads when you sign up for our newsletter at **IMPACT-books.com**.

35

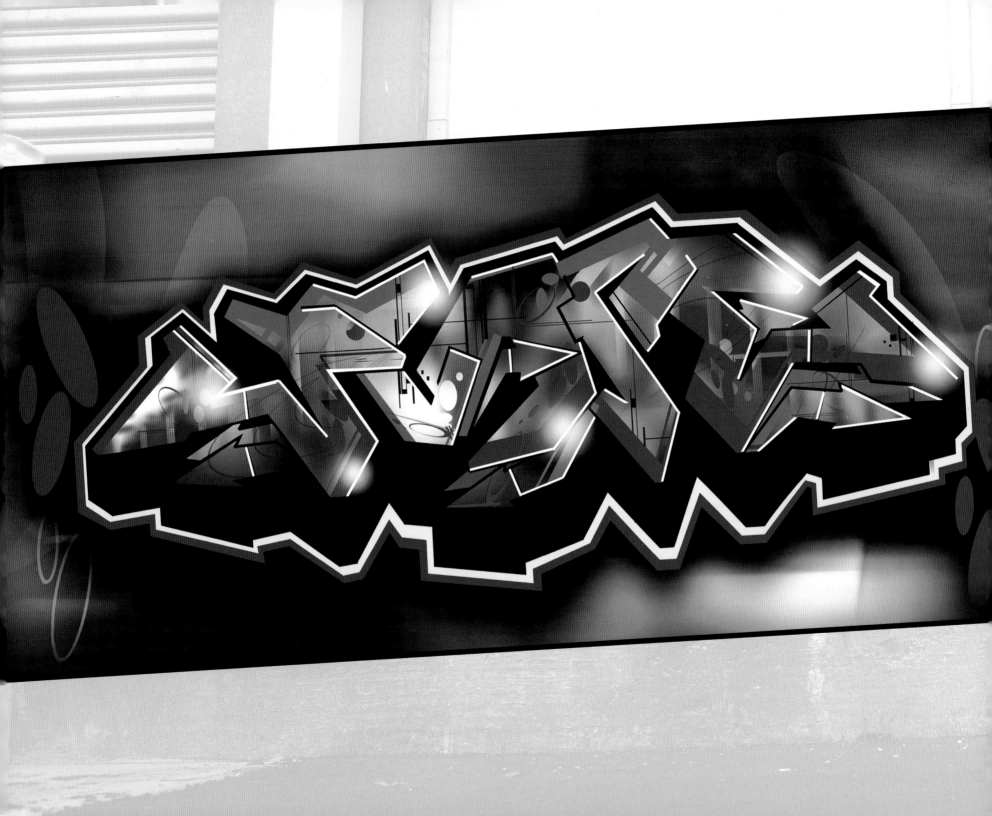

# 2 NEXT LEVEL OF STYLES: LETTER DEVELOPMENT

Graff writing has taken many leaps forward because of the abstract style and its various substyles. Working in this realm will enable you to step up your graff development and create work that is truly unique in an otherwise crowded space.

In this section, we will explore the various style elements involved in abstract letter development. Some concepts are more advanced than others, but none of them are absolute. The main goal is to begin thinking differently about letters and your relationship with them.

# BE THE ABSTRACT ORIGINAL

In the abstract style, letters can be broken up with portions of them left missing, leaving your mind to fill in the blanks. They can also be broken into complex forms and shapes, with colors developed for their own expression and not solely a particular letter style. In extreme abstract graffiti, the piece will not look like anything recognizable.

### Lowercase A

The actual letter style is pretty basic, but it's flipped in a couple of ways. The outline of the letter is broken up. Having an incomplete outline opens up your creative possibilities. You can take liberties with your lines and the slices, continuing to break them up into their own style elements.

### Uppercase E

This letter is comprised of three basic line configurations separated by blank spaces. Each of the three line elements is rendered in a different color: one red, one green and one blue.

### Uppercase E

Here is another version of an *E*, in full color. Note how the outline of the letter changes throughout and becomes part of the fill-ins and the background. Trace the yellow through the piece and notice where your attention goes. Do the same with the red and the magenta colors. You can then take those colors and fade them out with your shadows and blends to create something new and visually stunning.

# LYRICALS

Lyrical letters are formed with a lot of curves and dynamic movement. They have few straight lines, and appear to spin and flow, possessing lines similar to those found in the strokes of traditional cursive handwriting. They can be based on strands and filaments of color, and work well with glows, allowing you to create some visually stunning work.

### Compare Letter Styles
An uppercase, block-style *A* is paired up next to a very ornate Edwardian script-style *A*.

### Compare Letter Styles
Compare a block-style uppercase *B* with a cursive-style *B*.

### Combine the Styles
The movement of the block-style letter is combined with the scripts and flows of the Edwardian-style letter, resulting in a flowing, lyrical letter with very few straight lines.

### Combine the Styles
This is where we end up. If you look closely at the letter, it's really just a series of arrows, bent and positioned to create the *B*. You can easily do the same with some practice.

Free downloads when you sign up for our newsletter at **IMPACT-books.com**.

**39**

# COMPUTER ROCK

Imagine taking a knife to your letters and literally taking a stab at them—cutting, slicing and repositioning the pieces to create something altogether different. That's the core of the computer rock style. Letters are very straight, hard-edged and geometric looking, with lots of sharp edges and angles. Connections and extensions tend to run in parallel directions. Letters are pushed out and then pulled back at really sharp angles, overlapping and intertwining the pieces together.

Legibility is not a concern when working in this style. All the pieces and bits can drop and fall behind each other, creating a composition that can look very industrial or futuristic.

## STYLE SEGMENTS

### Keep Angles Tight
Letters are straight and hard-edged with tight angles. A zig-zag approach is taken with the slices.

### Incorporate Movement
Getting more intricate, the slices trace the inside of the letters and shift from left to right to imply letter movement.

### Use Connections and Bits
This segment of a letter shows how a connection can be brought off the side of the form, then sliced into bits that cascade away from the letters.

### Drop Slices
The slices are cut and dropped behind each other, like playing cards. The arrows and slices have a common focal point, minimizing the chaos.

### Push and Pull
Elements are pushed and pulled out, then brought back at hard angles, creating an architectural or robotic appearance.

## LETTERS

### Computer Rock *S*

The letter is cut in half, and the two pieces are rendered independently of each other. They are then rejoined and intertwined. All angles are a sharp 45 degrees, and the corners are cut to make them blunt. The final composition looks robotic.

### Computer Rock *E*

The arrows are hidden behind the letter, just peeking out from the left and right sides. Curves are kept to a minimum. Parallel lines and sharp pointed arrows are hallmarks of the technique here.

## WORDS

### *Deadly*, Black and White

My computer rock-styled take on the word *deadly*. Can you make out all the letters? Note the way the arrows shoot from left to right. Some of the arrows appear to be coming out of nowhere, but this is all part of the style's psychology—tricking the viewer's eye with intricate letterforms.

### *Deadly*, Color

Here are the same letters with a bit of color added to create even more visual impact. Letters like these lend themselves well to backgrounds that are geometric in style. You can also create a more complex composition by using color inside of the letters to replicate the movement of the letters, angles and arrows. I kept it relatively simple here to illustrate the aesthetic points.

## Abstract Letter Development
# MECHANICALS

Mechanical letters are powerful letter formations that are streamlined with elements including straight bar-like forms, strong thick descenders and ascenders, draft-like architectural qualities, and lots of overlapping elements. The emphasis is on more, meaning more extensions and connections, sometimes stretching clear across the letterforms. All the bars of the letters overlap, and there are few curves, if any.

Follow the steps to create mechanical letters. We will explore two different processes, morphing and visualization, to achieve the same end result.

### Morphing
When morphing, begin with a basic block letter and transform it step by step to reach your goal.

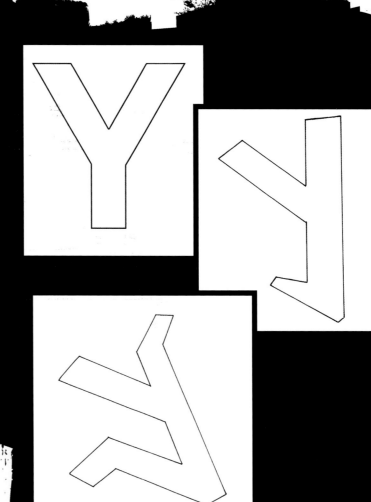

**1 Begin With the Basic Block Letter**
Study the block letter in its standard form and begin thinking about the type of movement that you can create by pushing and pulling parts of the letter.

**2 Straighten and Shift**
Straighten out the right side of the letter and shift its base to the right. This will provide a different structure to build off of. Add a serif at the base.

**3 Tilt and Bend**
Tilt the letter body to the left a few degrees. At the tip, bend it back just a bit, and then push the serif out, transforming it into an extension.

## DON'T RUSH IT

Take your time when refining your letters and fixing your flows so you can see your style advance and improve.

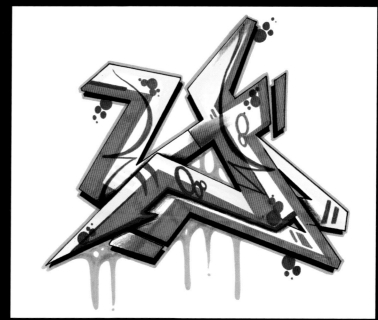

## 4 Spread Extensions and Add Serifs

Take that same extension and spread it out a little. Make it wider at the end and slightly narrow at its base. Bring the serif down a bit to make the letter more compact. Then bend back the right arm of the Y and add a serif to its top. Now you can really see the letter transforming!

## 5 Tighten and Tweak

Begin to tighten everything up. Squeeze the serifs down a bit. Push the bottom corner down and out, almost to a dull point. Bring the arm of the Y down and push it through the back of the letter, making the outline appear more intricate.

## 6 Add Bits and an Arrow

Add a few bits to the letter and an arrow in the center, coming out of the base. Note that this arrow runs parallel with the lower leg of the Y. When letter elements can be made to run parallel, it's easy to section them off and create arrows and other extensions.

## 7 Add Color and Shadows to Finish

Finish by adding your color patterns and a drop shadow. Note that even when the letter is flat as opposed to 3-D, you can still add shadows where the elements overlap.

Free downloads when you sign up for our newsletter at **IMPACT-books.com**.

**43**

## Visualizing

With visualization, have the finished letter pictured in your mind and begin with a rough sketch of the finished form.

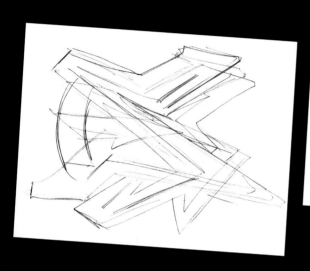

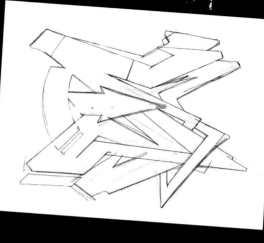

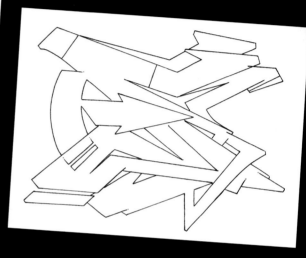

### 1 Sketch the Visual Concept

Have a loose concept of the finished letter *S* visualized in your mind. Lay down a sketch with a series of parallel lines, some straight and some curved. This will keep your letter accurate and balanced.

### 2 Darken Lines and Tighten Angles

Darken the parallel lines you want to keep and erase those that you don't. If you make your letter too thin you won't be able to add fill-ins later, so keep your lines thick and let them overlap. Tighten up the angles and overall form of the letter so there isn't a lot of negative space in the construction.

### 3 Outline in Marker

Outline the letter with your permanent marker. Erase all unneeded sketch lines, leaving a strong black-and-white letterform.

### 4 Add 3-D

Add your 3-D and drop it straight down, giving extra attention to areas inside the letter.

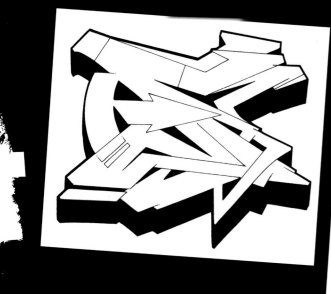

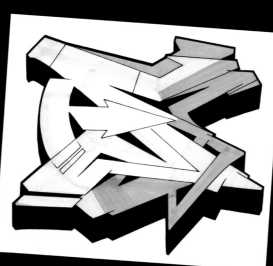

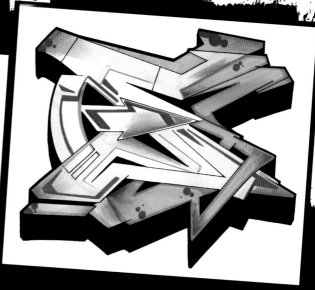

## 5 Fill In 3-D and Add a Stroke
Fill in your 3-D in solid black. Do a black stroke around the letter. It should now look solid.

## 6 Add Color
Drop in your first elements of color. Keep in mind that in graffiti white is also viewed as a color, not the absence of color. In this case work both with it and around it, adding yellow and light blue, letting the white sit in the middle. Add your colors in large blocks.

## 7 Add Effects and Accents
Add effects and accents with magenta and blue. Add your effects to accentuate the primary blocks of color you added earlier. Shape some of the blocks with blue to bring them out, and use magenta to bring attention to the shape of the letter. Add dots and bubbles and a few fades here and there.

## 8 Add Shadows and Glows to Finish
Add shadows where the letters overlap. Add a light blue glow for some added pop. Drop some clouds into the background, and add more dots and a few drips to complete the composition.

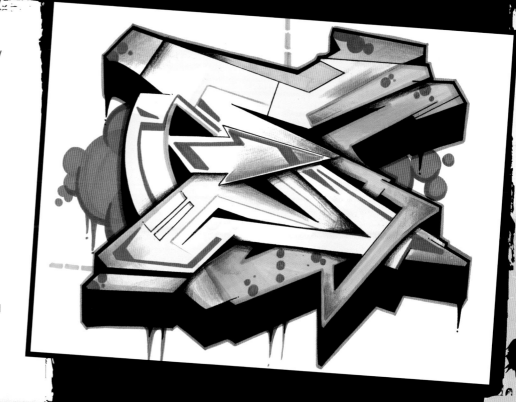

# Abstract Letter Development

# RADICALS

With radical letters the idea is to look at the form and shape of the entire letter and wholly reconfigure and redefine it, pushing and stretching the letter until a new form is developed. Radical letters tend to be thick, with very little dependence on arrows and extensions.

Follow the steps to create a radical e.

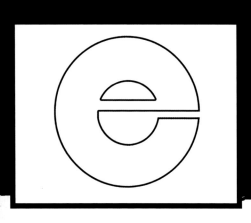 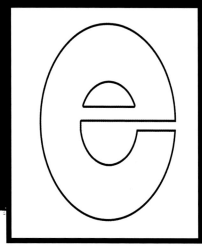 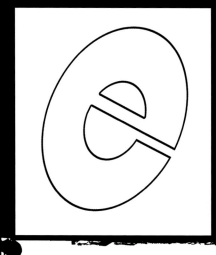 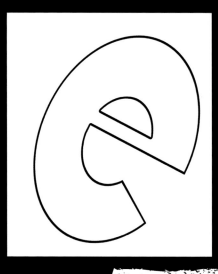

**1 Sketch the Letter**
Sketch a basic letter e, lowercase and thick.

**2 Stretch It Out**
Stretch the letter out, elongating it to create more of an egg shape. The trick is to think outside the box. Challenge the notion as to what an e can be.

**3 Tilt the Letter**
Tilt the e forward while still keeping the basic integrity of the letter.

**4 Remove a Section**
Remove a section of the lower hook part of the e. (If it weren't for the bar going across the letter, it would now look like a lowercase c.)

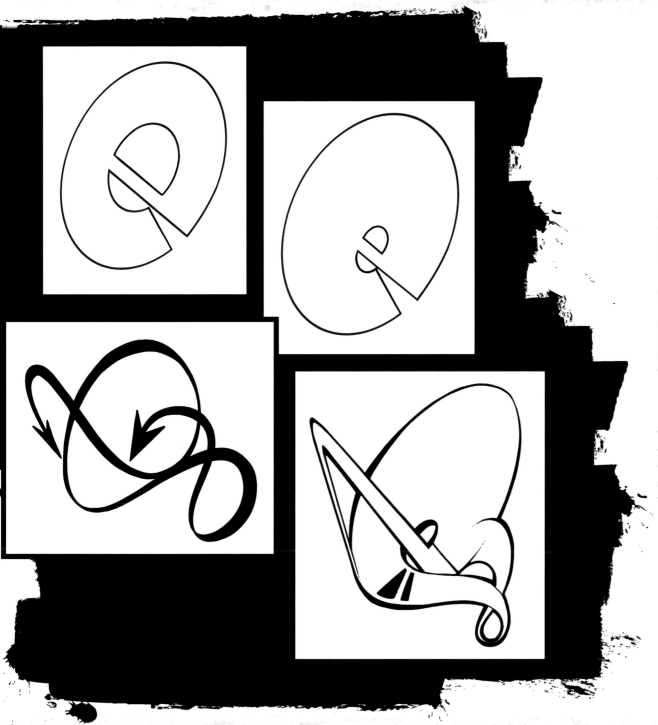

### 5 Drop the Crossbar
Drop the crossbar down so that it almost touches the lower mouth of the letter.

### 6 Modify the Negative Space
Look for the negative spaces in and around your letterform. Shrink down the opening of the *e* and line it up with the lower opening of the letter.

### 7 Step Outside the Box
Begin thinking about the type of flow or movement that can be added to the letter as a motif. This ink sketch details some movement that would add a lot to the development of this *e*. Use it as a guide to transform what you've already done.

### 8 Combine Style and Form to Finish the Letter
Take the previous two forms and combine them. Keep the form and body of the basic letter, but take direction from the ink sketch, picking up the twists and turns and morphing them into the style. Drastically change the line weight all around the letter.

Free downloads when you sign up for our newsletter at **IMPACT-books.com**.

47

# 3-D WILDSTYLE

Three-dimensional wildstyle is one of the final frontiers in the world of abstract graffiti. Understanding this style will open the door to many new levels of letter development and color patterns.

The phrase "exaggerated space" is a good way of thinking about letters in this style. The dynamic nature of 3-D wildstyles is based on the trinity of light, shade and shadow, and how those three properties play with the form, the actual body of the letter.

## Literal
A very basic 3-D letterform. Notice the added letters in the 3-D.

## 3-D Wildstyle
A more advanced take on the letter *S* with some of the forms stretching around each other to add the wildstyle element to the letter.

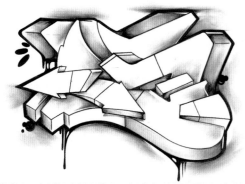

## Abstract
The letter *S* broken up into its various geometric shapes, with those forms skewed and rearranged.

## VISUALIZE THE BIG PICTURE

Visualization is your friend. Master the skill of creating a mental picture of the composition and then executing it. Many artists find it helpful to use extra sheets of scratch paper in order to properly visualize and comprehend their 3-D forms.

Keep in mind the shape, space and movement that are created when manipulating your letters. Think of your composition in total, as a whole. Don't get bogged down on a single letter or portion of the piece.

## Face or Front Letters

The following examples show the concept of creating letters with a face or a front. The face of the letter is the area where proper fill-ins can be added. There is a clear distinction between what is and what isn't 3-D.

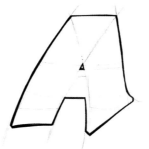

## Basic

Here is a fat letter *A*, slightly curved with a little bit of style. (The pencil lines running through the letter will serve as guides for breaking the letter into sections later.)

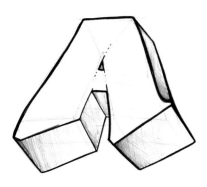

## Add 3-D

Basic 3-D is dropped in, seen here in shades of gray. Notice how the line weight changes as it progresses.

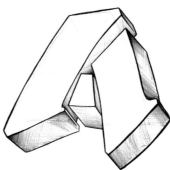

## Cut It Up

Following the pencil sketch lines, the letter is cut into three sections. The lower sections of the letter are angled out, and serifs are added.

Moving forward, each section is treated individually, but is still part of the greater composition.

## Shift and Slice

Some pieces of the letter are shifted to the front and others to the back. The top and bottom of the first bar and the crossbar are sliced to create bits.

## Add Arrows

Elements of style are added to each individual piece. An arrow is added, and bits and slices are shifted. Each element is curved and now flows. Flow is very important because it keeps the integrity of the letter together.

## Outline and Finish

More arrows are added, and a thick outline ties the whole letter together. The face of the letter and the respective 3-D of each section is clear.

Free downloads when you sign up for our newsletter at **IMPACT-books.com**.

**49**

# W IN 3-D WILDSTYLE

Now let's execute the 3-D wildstyle in another fashion. In this case, the end result will not have a proper face on the letter, so we deal more with the overall shape and feel of the form. It is a bit more sculptural in look and feel.

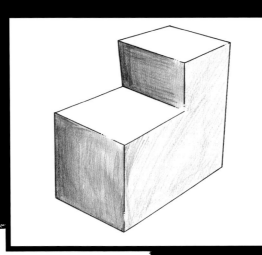

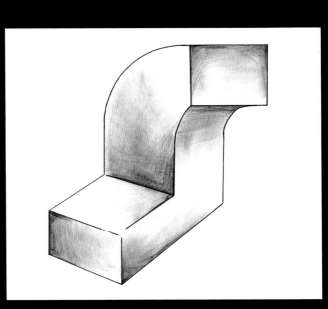

### 1 Begin With a Cube
Draw a basic cube, the easiest way to express the core of 3-D—length, width and depth.

### 2 Stretch the Cube and Add a Form
Stretch the cube and add a form to the top, creating a shape that looks like a step.

### 3 Twist and Push Downward
Add the first twist to the form. Pushing the main cube downward, create a base and then stretch the top over to the right.

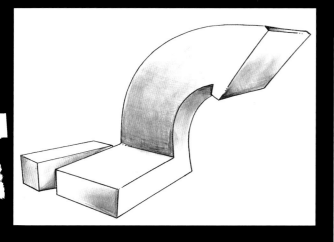

## 4 Add a Slice and Serif

Add a slice to the left of the base, and add a serif to the upper right. We can begin to treat each element individually, but keep in mind the endgame.

## 5 Modify the Serifs

Point the serif back to the right and slice it off. Take the slice on the left and curve it over the base of the form. Add the drop into the center of the form. The letter is taking shape now.

## 6 Add More Serifs, Slices and Forms

Push the drop down and slice it off. Add a serif to the left side. From the serif, add a slice and extend it. Add another form behind the letter.

## 7 Tighten Up and Add Finishing Touches

Tighten everything up and add final touches by bringing all the disparate pieces closer together and adding bits and slices throughout. Balance is very important here. Keep an eye on all the little pieces and make sure they represent the final idea—the letter *W*.

# DOUBLE VISION

Double vision is an advanced style of graffiti lettering that has been hidden in obscurity for years because of its brain-wracking complexity. In the double vision style, a letter composition has simultaneous meanings within a single sketch. The wordplay can happen from left to right, or right to left. It can occur as a mirror image, or by flipping the letters 180 degrees. Double vision can be executed in any number of ways, but the key is that it happens deliberately as part of your message.

There are so many nuances involved in double vision, I could write an entire book on that style alone. So this lesson is to serve as a simple taste of the technique involved in creating the style.

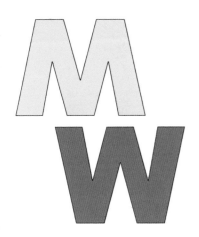

### One Letter, Two Possibilities
A yellow *M* and a blue upside-down *M*, which for many translates into a *W*. This is where the double vision comes into play. You can create a word that contains an *M* one way, and a *W* when viewed in reverse.

### Take Another Look
The yellow *M* and blue *W* are laid on top of each other. The area where they overlap is shown in green—notice that you get an image that appears to be a reversed *N*. That too can play a role in the way you structure your new letterforms.

### Double Vision Take 1
Let's try it again, but this time with words. Here we use the word *GRAFFITI* in all caps black text. Underneath in gray text is the same word in reverse. In order to read it you need to view it in a mirror as a reflection.

### Double Vision Take 2
Here the words are overlaid on top of each other. This is where you would need to see how the letters work together, and how to morph and stylize the letters to make it rock.

## Flip the Style

After looking at how your letters and words interact with each other, take it up a notch to incorporate wildstyle!

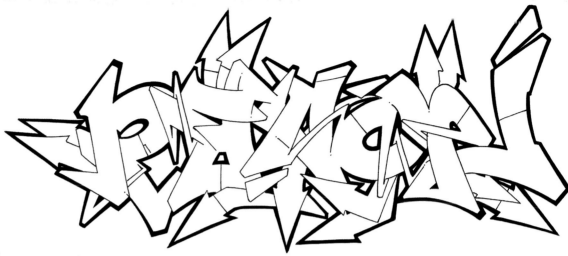

### PEACE

In this maze of arrows and connections lies the word *PEACE*. Letters were stretched around, like the *E*. The way the *P* is sliced makes it look like it could also be an *R*. These little improvisations have a purpose, because when you reverse the letters it reads…

### PLAN AND IMPROVISE

Your style begins with ideas formulated in your mind. Stimulate your imagination by sketching those ideas on paper. Your sketches don't have to be an exact representation of what will happen on the wall. Think of them as outlines representing the concept, and remain open to improvisation when you get to the wall later on.

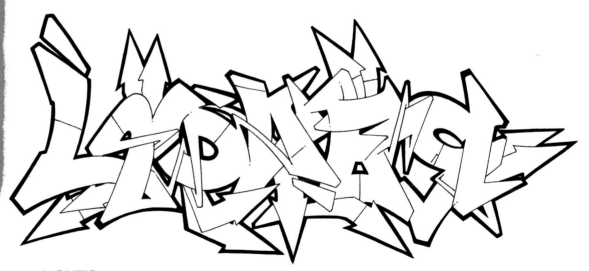

### LOVES

… *LOVES*. So it reads *PEACE LOVES* all in one composition. Notice the way everything is deliberate. There isn't a lot of room to add style elements purely for decoration.

Free downloads when you sign up for our newsletter at **IMPACT-books.com**.

**53**

# 3 FROM SKETCH TO PIECE: WORKING ON WALLS

It is my belief that by your very nature as a human being, you are born an artist. You are a creative entity, and your love of graffiti art is an extension of that. So, when you make your leap from paper to walls, you need not be intimidated or unsure in any way. The same confidence with which you held your pencils and pens is the same confidence you should have when holding your spray cans. If you can do it on paper, you can do it on a wall. It's all about technique and preparation, and it is all an extension of the creativity you already have inside you.

In the following pages we will explore styles, ideas, and techniques for working on walls. Some may be familiar to you and some may not. Just keep in mind that this is how I do my thing. You may see things differently, and that's great. Make it work for yourself on your own terms. I am simply a creative guide pointing out a direction. It is my hope that you'll gain some insight and learn new things, and that you'll be inspired to improve your own spray painting techniques and create spectacular art of your own.

So put down the pencils and pens and get ready to make your leap.

# CAN CONTROL

Learning proper can control is critical. It goes beyond simply how to hold the can; it helps develop a relationship between you and the paint.

There are differences in can pressure; some are high and some are low. Likewise, can caps also vary from high-pressure, juicy fat caps, which are great for fast fill-ins, to low-pressure thin caps, which work well for outlining and detail work.

The way you maneuver the can itself and the amount of pressure you exert on the can tips also affects your final result. Over time you will learn to develop ways of creating streaks, blurs and splatters, all by controlling the pressure—a light touch for fading, quick wrist motions for streaks, or angled sprays for shadow effects. But it all stems from intuition and practice.

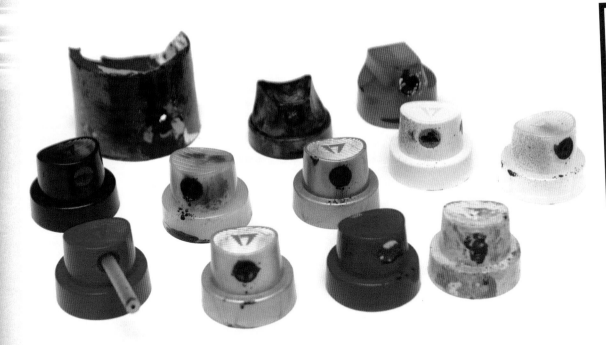

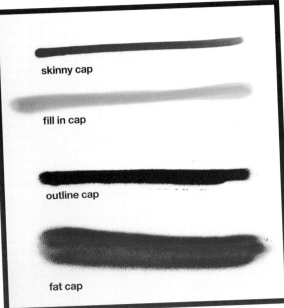

skinny cap

fill in cap

outline cap

fat cap

### Don't Forget Your Caps
These four colors represent four types of spray cap widths, from skinny cap (blue) to fat cap (red).

# Can Control Techniques

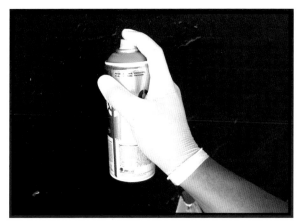

## Parallel

Negotiate the distance between yourself and the wall, and the can and the wall. The paint stream will flow straight ahead. Swing the can left to right to get a clean flow.

## Angle

The can is tilted at an angle. The paint flow is still straight, but because of the angle the can pressure changes. Also you can control the direction of the flow as you work the can with your wrist.

## Upside Down

With a twisting motion of the wrist, you can create fades and control the direction of your paint flow.

## It's All in the Wrist

Keep your arms relatively stiff and move only your wrist to control intricate fades and create arch effects. Using small spray cans works well for this, since they won't butt up against your wrist.

## Up Close and Perpendicular

The can is held perpendicular to the wall and very near it. So the paint will flow closely along the wall, leaving a hard edge on one side and a fade on the other.

Free downloads when you sign up for our newsletter at **IMPACT-books.com**.

57

# CUTTING

Cutting is used when the artist wants shapes, objects or letters to have crisp edges.

## PALETTE

black, white

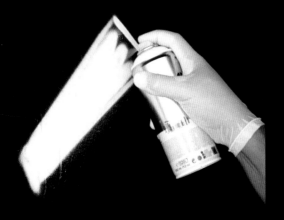

## 1 Outline the Bit

Use white paint on a black surface to create a bit. Do the outline first and then fill in solid.

## 2 Complete the Bit

At this point the finished bit will look rough along the edges. You cannot always control this. Sometimes it just happens, especially in situations where you are working with white on black.

## 3 Begin Cutting

Cut the shape going along the edge in black. Hold the can very close to the wall at a slight angle to get a crisp, clean line.

## 4 Continue Cutting to Finish

The completed object, crisp and clean.

# SHINES AND STAR-LIKE PATTERNS

This technique can be applied to a wide variety of uses, including letters and character elements, such as eyes.

## PALETTE

black, electric blue, white

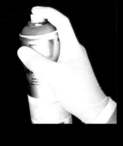

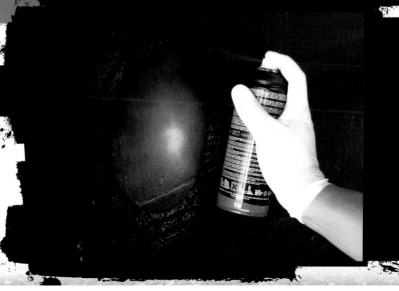

### 1 Begin With a Light Splash
Lightly spray a splash of blue on the wall.

### 2 Pull Away
Pull away from the wall to widen the spray.

### 3 Drop In White
Drop in white from a distance.

### 4 Cut In a Circle to Finish
Using black, cut in a circle around the fade.

# BURST PATTERNS

Simply holding the can at various angles can produce great effects.

## PALETTE

light turquoise

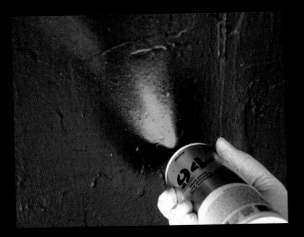
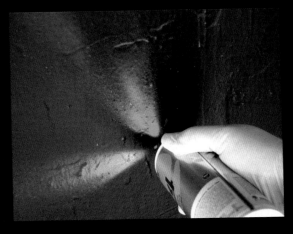
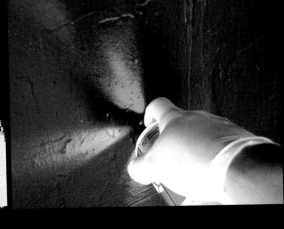
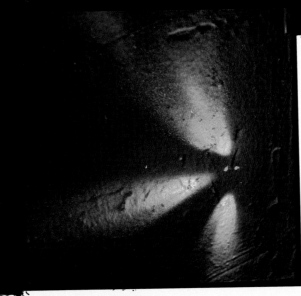

the completed burst

### Angle the Can
Hold the can up close and perpendicular to the wall and let out some spray. You will get a triangular spray pattern.

### 2 Change Your Angle
Point the can at a different, slightly upward angle to create a radial spray pattern.

### 3 Continue With Alternating Angles
Continue along, alternating your angles to create various burst-like patterns.

# FLARES

Combine nozzle pressure and wrist movement to create a flare effect.

## PALETTE
light turquoise

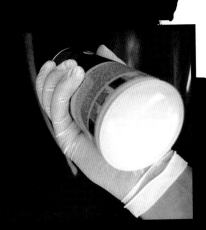

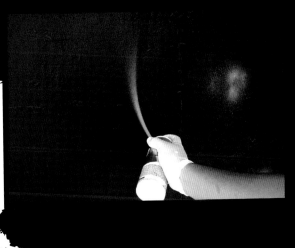

## 1 Spray Up Close and Upward
Start with the can up close to the wall and shoot the paint in an upward motion.

## 2 Move and Twist
Quickly move the can and pull away from the wall with a twisting motion to create the flare.

## 3 Pull Away
Complete the twisting motion with your wrist and pull completely away from the wall to create an effect that is tight at the base but flares on top.

the completed flare

Free downloads when you sign up for our newsletter at **IMPACT-books.com**.

61

# COLOR IN THREE DIMENSIONS

Let's explore and conquer the world of 3-D wildstyle, with a twist!

The letters for this piece will be done in 3-D and wrapped 90 degrees around the side of the structure. Other visual elements will also come into play, such as contrast, balance, sense of depth, shape and form. The purpose of this piece is to understand what's involved in working 3-D letters that go on top of a 3-D surface, and how those two elements interlace. The tricky part is that you won't be able to see your piece all at once as you work on it, because you can't see around corners.

From a creative standpoint, an artist can have a lot of hindrances. This lesson is designed to set a few up and help you get over them. Creative challenges are actually opportunities for you, the artist, to explore something new and fresh and to look at those challenges as a way to stretch your skills.

We will work with the word *FEAR*, a nice tasty word with a whole lot of weight, meaning and significance.

## FREE BONUS DEMO!

Check out Scape's demo on how to prep a wall at http://Graff2.impact-books.com

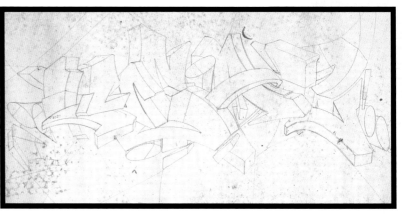

## PALETTE

black, blue, burgundy, dark blue, dark green, deep purple, light blue, light green, light pink, orange, medium blue, medium green, purple, red, white, yellow

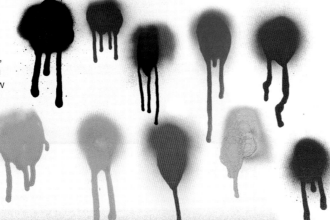

## Sketch

Because the surface we are going to paint on is at a 90-degree angle, we want the artwork to wrap around the edge. Study your sketch and decide where the piece can be folded.

It is important that you take your time when doing your sketch. Depending on your skill level and the intricacies of the artwork, you may need to do two or three sketches.

## Step 1: Prep the Wall and Sketch Your Piece

**1** Prep your blank canvas with yellow on one side and purple on the other. Don't worry about door hinges, handles or any seams on the surface. If you look at the second picture you can clearly see the two colors collide because of the level of contrast. You want that—it's going to play a role in your composition.

**2** Use a fat cap to lay down three loose, fat horizontal lines across the surface as guides for where to place the letters. They should be broken up segmentally, and do not have to be perfect.

**3** Using the lines as a guide, dive in and do your sketch. Do the letter *F* on the yellow side, and the rest of the letters on the purple side. Keep your arm steady as you work and pay close attention to what happens at the edge. Do not lose the perspective of the letters or let the edge distract you.

**4** Draw out one of the oval, tube-like elements of the work. Keep your hand close to the wall and keep the lines clean.

**5** Take a few steps back and see how it looks. If you can see where the letters are and decipher all the pieces and bits, then you will be OK. If you need clarity, go back and add that in at this point.

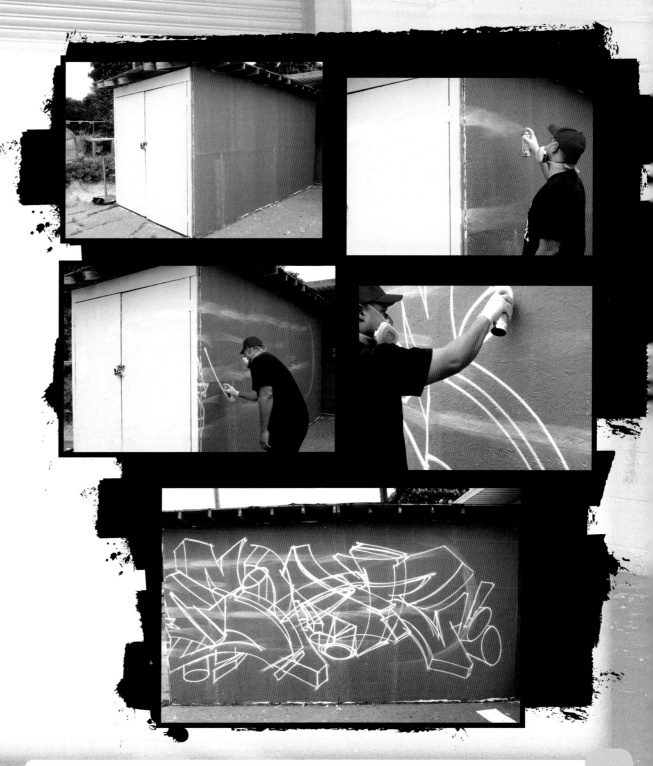

Free downloads when you sign up for our newsletter at **IMPACT-books.com**.

63

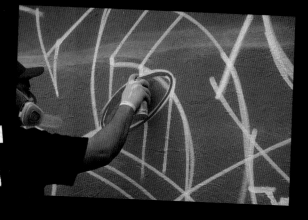
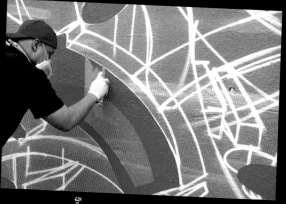
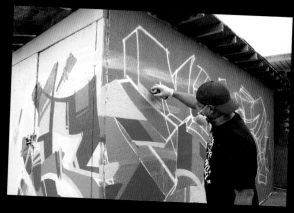
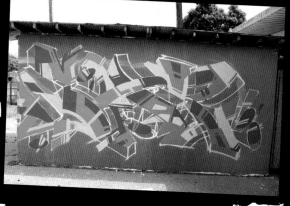
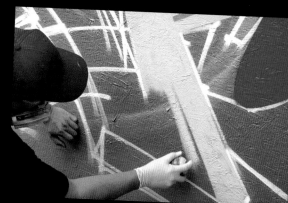
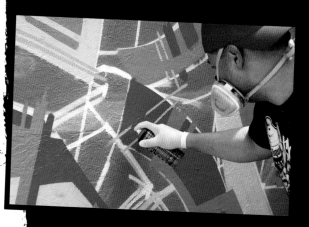

## Step 2: Begin Your Fill-Ins

Your fill-ins will be three different shades of blue, so you don't need to do multiple sketches. Drop in the blues in a hard block-style, fill-in pattern and keep the fades to an absolute minimum. As you go along, cut and slice as much as you can to keep both the fill-ins and the edges crisp.

1 Walk around the piece and work over the ovals. From this point on, work in your blues in modular steps of the three shades: light blue, medium blue and dark blue.

2 Come in with vertical strokes of medium blue. Keep the edges clean and crisp with no fades at all. As you work, continue to block out areas within the letters as was done with the dark blue.

3 Introduce the light blue. Look at how the blue works in the F, and how the letters bend over the edge of the corner. Pay close attention to the wall's edge. Make your spray strokes very precise here because you can get overspray from one wall to the next, which you'll only have to clean up later.

4 Take a few steps back and look at your work. Ask yourself, How does it look? How does it feel? Is something missing?

5 Use a fat cap here. This allows you to plow through and cover all the areas of light blue that you need to. Cover up what is underneath.

6 Add some crisp, slashing light pink lines through the piece. Use different angles, but make sure they are doubled up. Then cut through whatever respective blue color those pink lines are resting on. In this case, you'll use dark blue to slice through the pink.

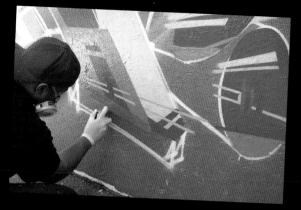
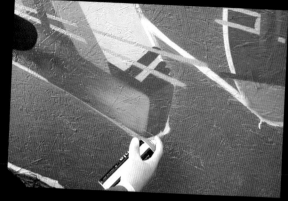
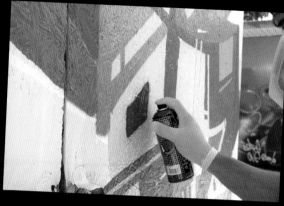

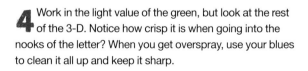

## Step 3: Work the 3-D

The letters in this piece have a face, or front, so the 3-D sections will have a unique colorway. In doing your 3-D you're going to need three shades of green (light, medium and dark), plus a bit of white.

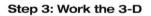 **1** Begin on the lower portion of a letter using the medium shade of green.

**2** Add light green to one side of the block. Remember the basics of shadowing—keep the dark green towards the inside or center of the letters, and the lighter green towards the outside, the light source. Be consistent in placing the darks and lights because this is what gives the illusion of depth. Sprinkle some white over the light green and repeat. Continue this process over the entire piece. Be patient and let the piece develop. Notice you are using the same techniques from the fill-ins here.

**3** While working the green, look for opportunities to add twists to the color patterns. In this case, add some red bits into the blues and cut them out.

**4** Work in the light value of the green, but look at the rest of the 3-D. Notice how crisp it is when going into the nooks of the letter? When you get overspray, use your blues to clean it all up and keep it sharp.

**5** Take a step back. Notice that the splashes of white are along the outer portions of the letters, where they would arguably catch the most light.

Free downloads when you sign up for our newsletter at **IMPACT-books.com**.

**65**

## Step 4: Work the Background

Because we want to blend our letters into the background and there won't be a glow, we can begin working the background. It is a good way to loosen up, since you will be working on some fades and blends. We know what the palette will be, since the point is to blend the black, which is going to be our outline, into the yellow and purple.

**1** Begin in the upper left corner of the piece, starting with the *F*. Outline the outside edge in black and blend that into the yellow. If you don't like the way it looks, you can soften it up a bit.

**2** Add a deep, rich burgundy. This is the first step to get the black closer to the yellow. You want to create a gradient of color, burgundy being the first in that attempt.

**3** Drop in some red. It will blend only with the burgundy. Don't use a lot of red, only a splash. Your eye will fill in the blank as you follow the red with orange.

**4** Take a yellow that matches closely with the yellow used to prime the wall. Blend it in to the right, going into the orange and red, and eventually touching the black. In the end you will have an elegant gradient, and you should be able to go around and complete this blend around the letters.

**5** Take a few steps back and check your progress. Note where the edges of the letters meet the black— they should be very crisp. Clean up and tighten your piece if needed.

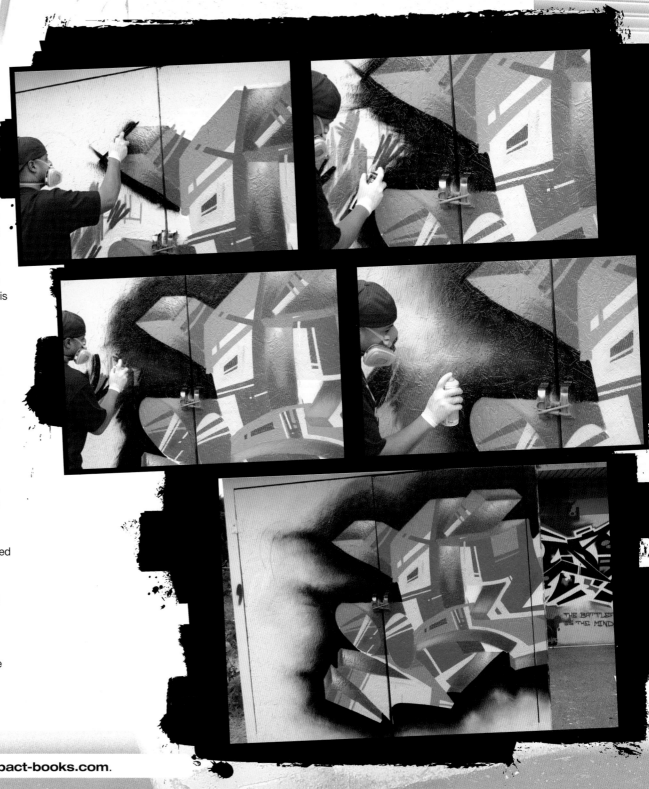

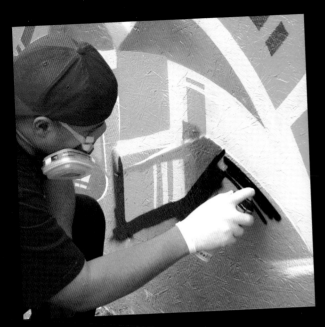
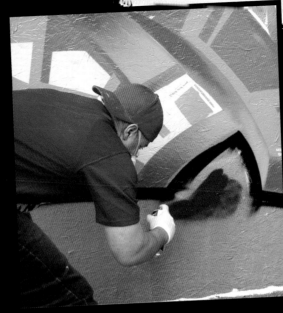
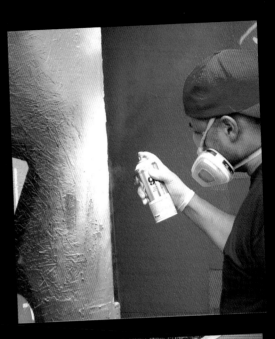

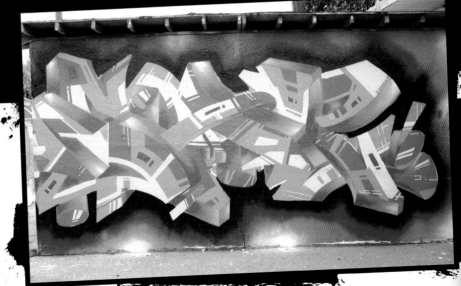

**6** Taking what you've learned in the previous steps, repeat the process on the purple side of the wall. Begin by doing the crisp black outline and fading it out.

**7** Now go in with a deep purple. Move slowly when doing your fades on the lower portions of the letters. You may want to work quickly because it's uncomfortable to paint crouched over, but if you do that you run the risk of the piece not looking the way it should.

**8** At this point you should see clearly how the gradients work. The black fades into two shades of the purple and then into the basecoat of the wall. Add in some white to maximize this effect, but only on the very edges where you can create little openings and drop it in.

Free downloads when you sign up for our newsletter at **IMPACT-books.com**.

**67**

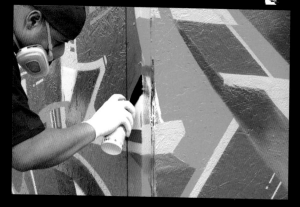

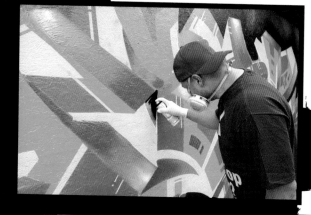
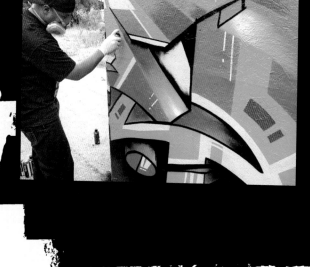
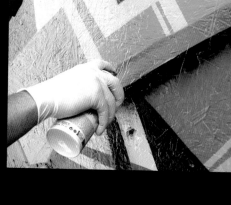

## Step 5: Outline and Fill In

Up to this point, you've been focusing on the outlying areas of the piece. Now it's time for more detailed work—doing the outline and filling in all the blanks in the piece.

**1** Starting on the yellow side, choose one of the many inside blank spaces of the letter pattern and fill it in with black. Be careful not to go over any of the green or blue. Slice out all the letter pieces and differentiate them from one another.

**2** This is a great snapshot of what you want to achieve. The parts are outlined and you fade out a portion so the illusion is that one piece is laying on top of the other. Sections can appear to emerge from behind other pieces.

**3** Repeat the same methodology on the purple side. Start in the central open areas with black and connect it to the outside areas. Basically you are connecting the blacks from both regions.

**4** It can be very tricky when working on the edge. Continue doing the outline and be conscious of the overspray. Keep your arm steady and work from the shoulder, keeping your wrist stiff.

**5** As you go along outlining, add shadows. Shadows are easy to overdo. Keep them going in the same direction, towards the dark areas of the piece. Keep your spray can at an angle to minimize overspray.

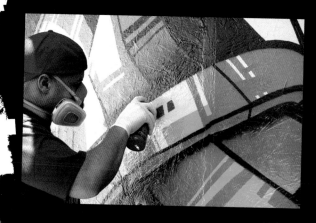
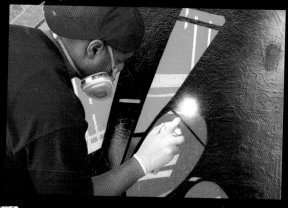
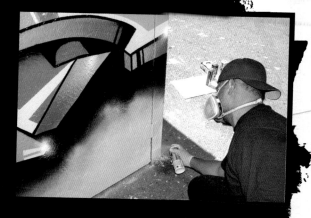

## Step 6: Details and Finish

You're almost finished! You just need to do some clean up and drop in the final detail pieces to complete the entire piece.

**1** Touch up your blue. Go over the piece and fix any little areas of overspray or crooked lines. Be patient and deliberate.

**2** Step away from the piece and decide where you can bring attention to it. Then go in with white and do your shine. Where you place the shines will move the viewer's eye all over the work.

**3** Go around the piece and drop some white in on the edges, especially where the yellow collides with the purple. This will accentuate the contrast between both walls.

**4** Tighten up with the black where needed. Walk over the piece, looking for any imperfections and tighten and fix where possible.

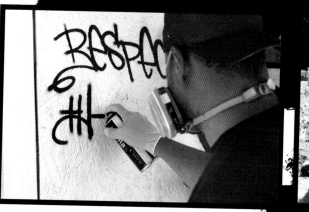
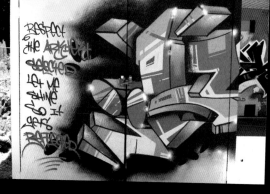

**5** Almost there! After all this work you may be too spent to even think of a quote, which happens quite often. Search for the right space, and write your quote with deep purple.

**6** Go back in with a true blue and rewrite over some of the letters to accentuate them. Make them stand out and push your message forward. What you say and how you say it is important.

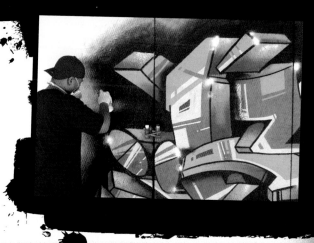

Free downloads when you sign up for our newsletter at **IMPACT-books.com**.

**69**

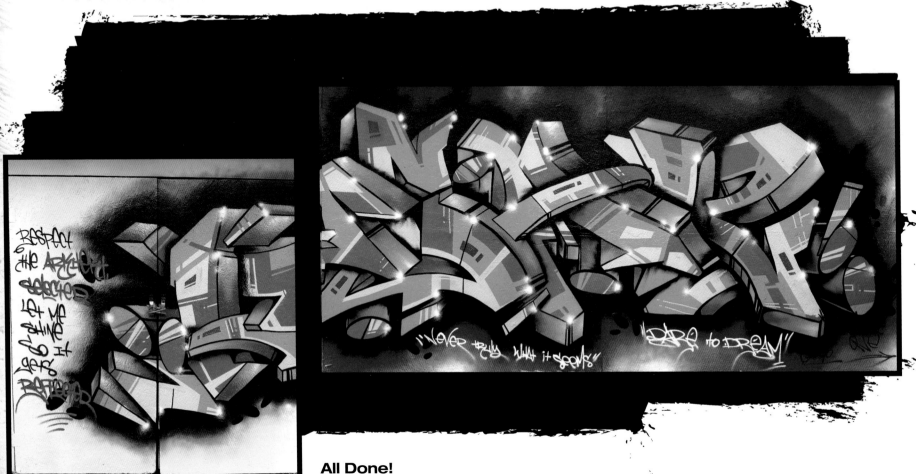

## All Done!

Lift your eyes, step back and give yourself a pat on the back.

In these images you can see just how different the piece looks from different angles. Notice the way the 3-D letters force you to renegotiate how you look at the corner.

If you focus on those differences from the start, you will have challenges. But you were aware of them and worked through them section by section. In working on this piece, you've most likely conquered a few creative fears and doubts that you've had. We all have them, but the idea is to push your boundaries. The sky is the limit.

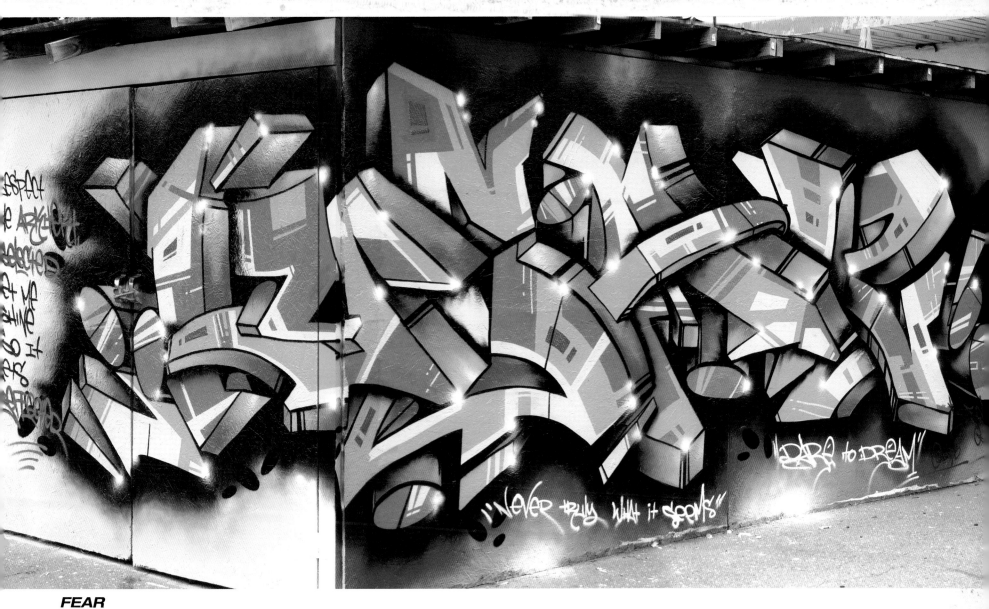

**FEAR**

*Respect the arkitekt, selected, let me shine so it gets reflected.*

Free downloads when you sign up for our newsletter at **IMPACT-books.com**.

71

# THE SHAPE OF THINGS TO COME

With this graffiti composition, we bridge two worlds. The eye has a realistic, almost comic book style, but the rest of the piece falls into abstract territory. There are multiple layers and many levels of symbolism. The eye takes the place of the letter *A*, following the graffiti rule that a symbol can take the place of a letter. The eye symbolizes sight, and it quite literally stares at you. But what is it saying?

As you develop your own graffiti pieces, keep in mind that the way you work your colors is interdependent with the way your letters are laid out. You want the letters to appear as if they're floating. You want the colors to be busy, but not so busy that people will get lost in the visuals. Strike a balance between the two. In this composition, I wanted the eye to be surrounded by warm colors, almost symbolic of the sun, and I wanted to have cool colors on either end. I used white as a blender for both. So in the end, I have this warm/cool vibe going on, with the black outlines tying it all together.

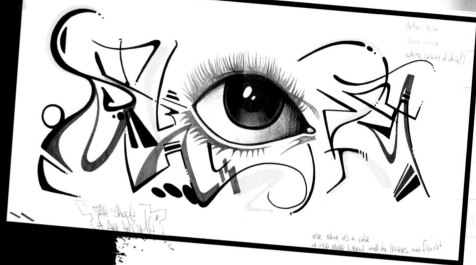

### Sketch
It is pretty naked, just the pencil sketch of the eye and a black marker outline. You may notice that I wrote some color ideas and instructions—these are like my music notes, telling me how I need to compose those colors on the wall.

## PALETTE
black, burgundy, dark blue, dark gray, light blue, light gray, light green, light orange, lime green, medium blue, medium gray, orange, red, turquoise, white, yellow

### FREE BONUS DEMO!

**Check out Scape's demo on how to prep a wall at http://Graff2.impact-books.com**

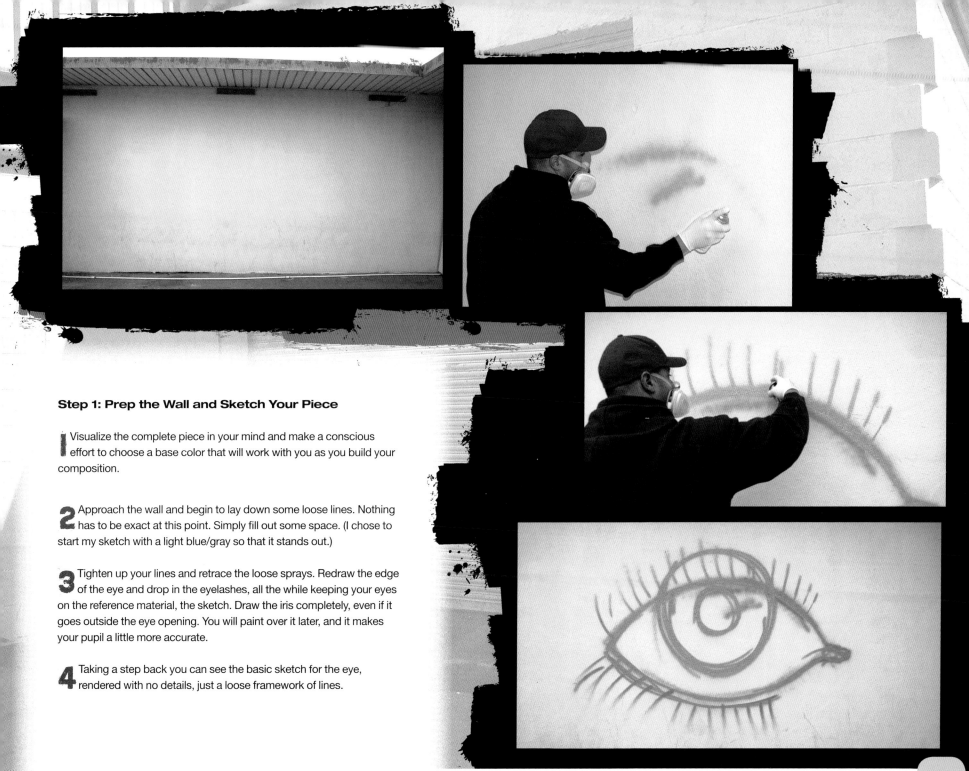

## Step 1: Prep the Wall and Sketch Your Piece

**1** Visualize the complete piece in your mind and make a conscious effort to choose a base color that will work with you as you build your composition.

**2** Approach the wall and begin to lay down some loose lines. Nothing has to be exact at this point. Simply fill out some space. (I chose to start my sketch with a light blue/gray so that it stands out.)

**3** Tighten up your lines and retrace the loose sprays. Redraw the edge of the eye and drop in the eyelashes, all the while keeping your eyes on the reference material, the sketch. Draw the iris completely, even if it goes outside the eye opening. You will paint over it later, and it makes your pupil a little more accurate.

**4** Taking a step back you can see the basic sketch for the eye, rendered with no details, just a loose framework of lines.

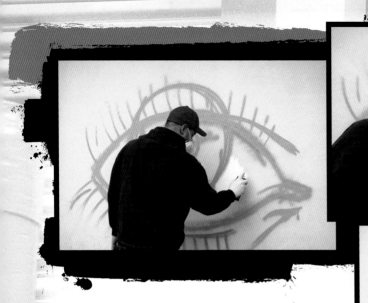

## Step 2: Work the Eye

**1** Begin filling in the eye. Take your time and work in strokes, laying down bands of color. Work from the center and fill in towards the outside edge. Cover all of your previous sketch work.

**2** Lightly dust the edges of the eye with light gray. Go in lightly with the gray; you'll have some land on the yellow and that's OK. Focus on fading that gray into the white. Go from light gray, to medium gray, to dark gray, and then to black. The goal is to build a gradient fill from dark to light.

**3** Keep your hand far back from the wall when working with the black. If not you'll run the risk of adding too much and ruining your work. When done with the black, you may want to drop a light dusting of the white again to make the gradient feel right.

**4** Drop blue in the iris. Pay close attention to the edge of the iris. You want it to have a very crisp edge where it touches the white.

**5** With a darker blue, add shading to the top portion of the eye. Work the can at an angle with a stabbing motion. Lay in the blue from the top and fade it in, moving your wrist in a downward motion.

You should have at least three shades of blue: the main base color, a shade a few values darker and a shade lighter. So the gradient you end up with is dark on top and light on the bottom, with the base color in the center.

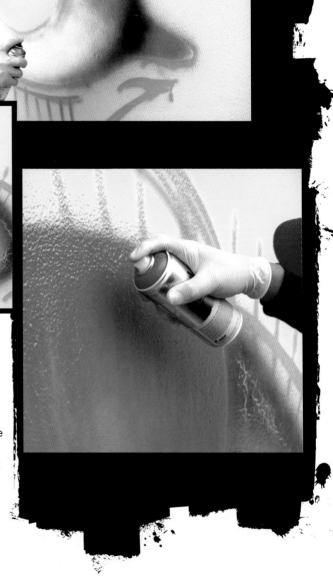

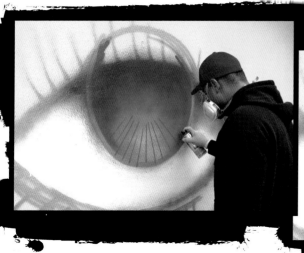

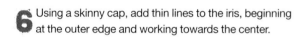

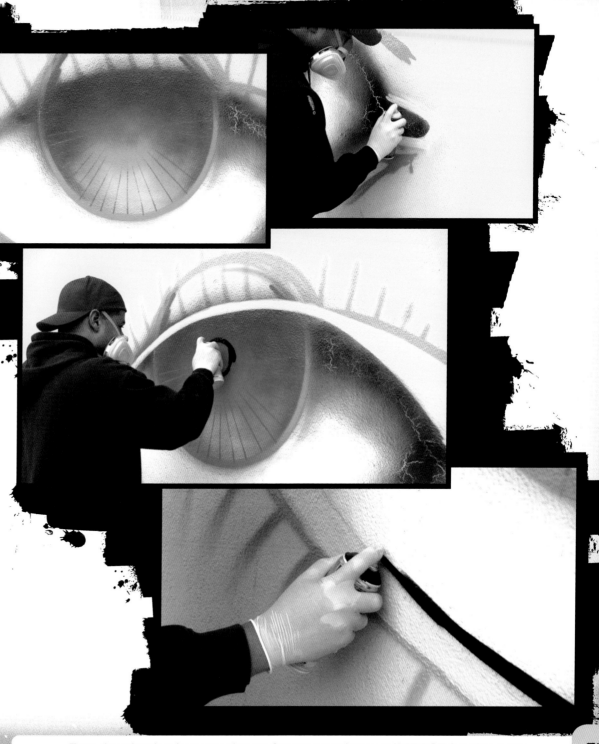

**6** Using a skinny cap, add thin lines to the iris, beginning at the outer edge and working towards the center.

**7** Fade in more black and a dusting of white in the iris. This will push those thin lines back and layer in the extra shading, giving the eye a sense of depth.

**8** Use a yellow that can pair up with the background. Carefully retrace the edge of the eye, tightening it up. This is a way to cut the eye out, cover the overspray, and blend it into the background.

**9** Drop in the pupil with black. Go in a steady and circular motion. Start out small and gradually make your black dot larger and larger until you reach the desired size.

**10** Begin to do the outline of the eye with black. Be steady with your hand and make sure you are rested and focused in this step.

Free downloads when you sign up for our newsletter at **IMPACT-books.com**.

**75**

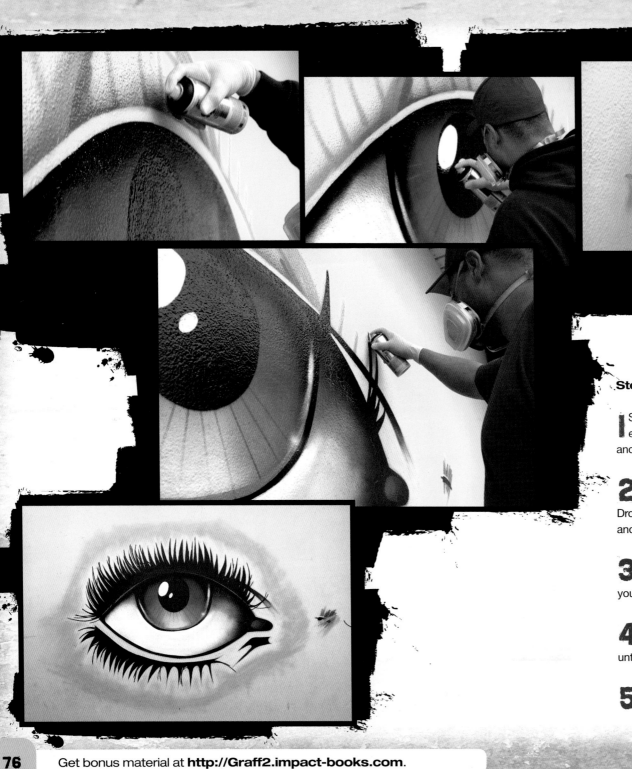

### Step 3: Complete the Eye

1. Still using the black, add a drop shadow to the top of the eye. Hold the can sideways so the spray is directional, and gently fade it into the blue with quick, painterly strokes.

2. Use white to add some shine to the pupil. This is the same concept as adding dots or bubbles to your fill-ins. Drop in some black along the edge of the iris to make it pop and increase the illusion of depth.

3. Work the eyelashes. Begin with the inner portion of the lashes, not the eyelashes themselves. Make sure that you cover all the gray.

4. Give each eyelash attention. Fluctuate from a thin cap to a skinny cap. Go back and forth all the way around until you are done.

5. Add an extra shade of orange-yellow around the eye to make it appear to float. The eye is complete!

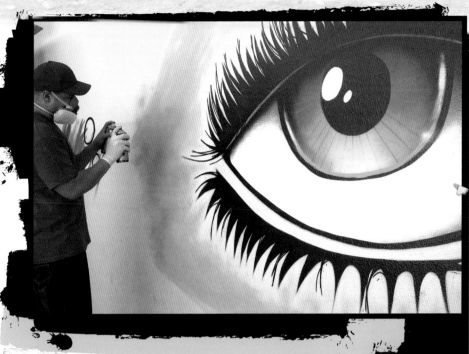

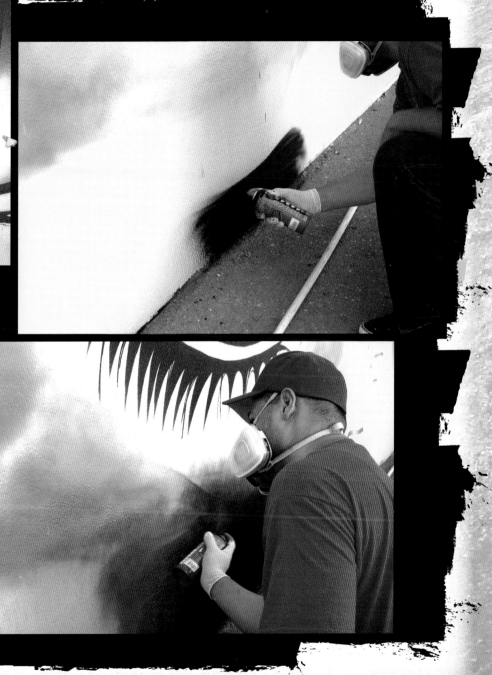

## Step 4: Begin Color Fill-Ins

Now you're going to have to fill all of that background with color. It's going to serve two purposes. For the eye it will be a background, but for the letters it will be a fill-in. Keeping that in mind, let the improvisation begin!

**1** Begin the background with two shades of orange, one in each hand. With this fade technique, spray *both* cans of paint at the same time, fluctuating the pattern from left to right. This way the colors blend in midair.

**2** Add another color as an anchor. Dive in with black and begin filling in the base of the wall.

**3** Add more color to bridge the gap between the black and yellow. Use burgundy, a little red, and orange. Work with a fat cap to create a wide-angled spray pattern. Add drips in a random fashion to give it a bit of texture.

Free downloads when you sign up for our newsletter at **IMPACT-books.com**.

77

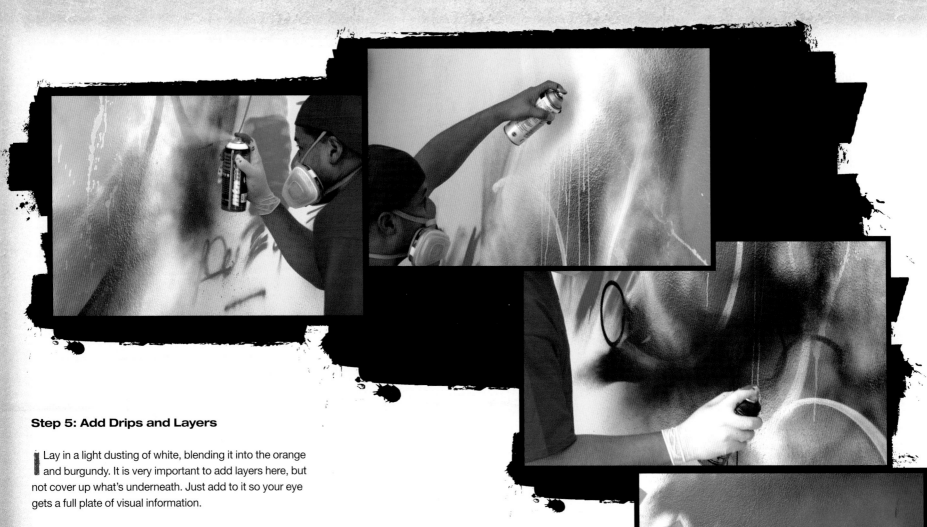

## Step 5: Add Drips and Layers

**1** Lay in a light dusting of white, blending it into the orange and burgundy. It is very important to add layers here, but not cover up what's underneath. Just add to it so your eye gets a full plate of visual information.

**2** Still using white, add major drips in key areas. Hold the can steady and close to the wall. With an extended spray, let the drips roll down. Fade out the impact portion so that all you see are the drips and not the splash patterns. Step back and review your work from a distance.

**3** Go back in with black. What is important here is that black is used as a color all its own, not just for shadows. Create some cloud-like fades. You should see your piece beginning to shape up now.

**4** Start from within the white areas and work your way toward the edges with blues. Add various forms and shapes. In this process you'll be using white and blue only, going back and forth as you move along in order to create the wanted fades and fills. This is a push and pull technique, meaning that you go in with one color, fade it out, then go back to the previous color and fade that on top. Do this on both sides of the piece to keep it balanced.

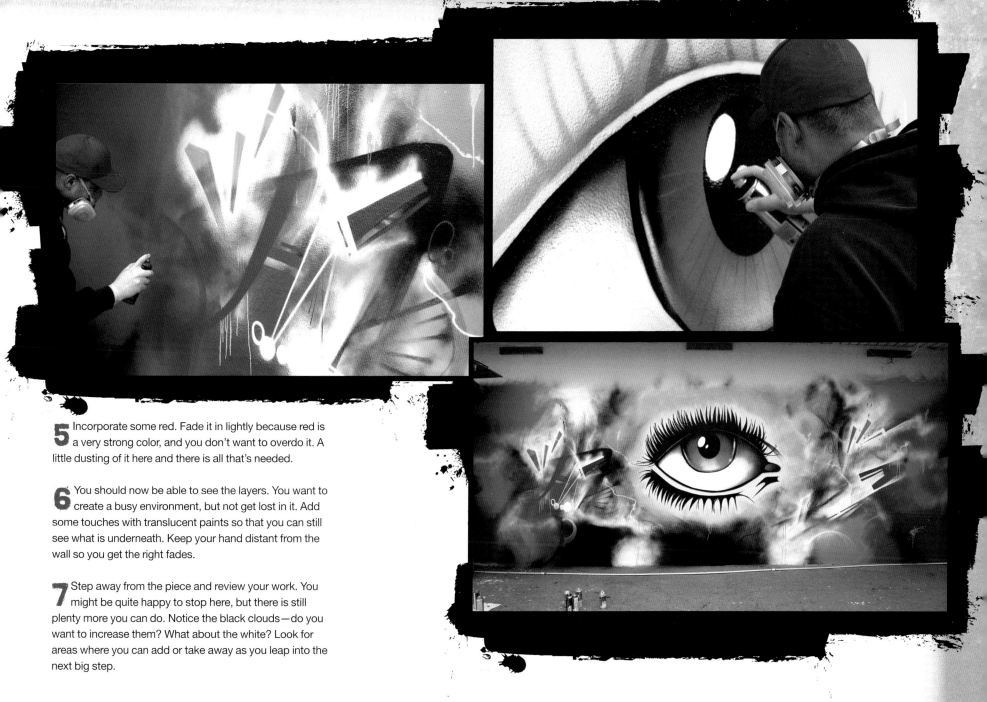

**5** Incorporate some red. Fade it in lightly because red is a very strong color, and you don't want to overdo it. A little dusting of it here and there is all that's needed.

**6** You should now be able to see the layers. You want to create a busy environment, but not get lost in it. Add some touches with translucent paints so that you can still see what is underneath. Keep your hand distant from the wall so you get the right fades.

**7** Step away from the piece and review your work. You might be quite happy to stop here, but there is still plenty more you can do. Notice the black clouds—do you want to increase them? What about the white? Look for areas where you can add or take away as you leap into the next big step.

Free downloads when you sign up for our newsletter at **IMPACT-books.com**.

79

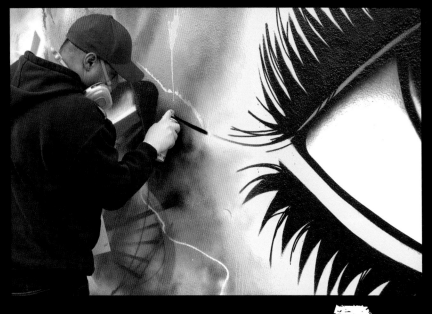

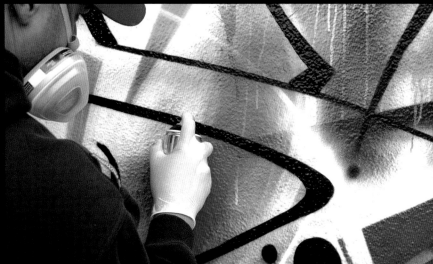

## Step 6: Outline and Drop In the Letters

Compare what you've accomplished on the wall with your sketch. You could change the color of your outline from what was planned in your sketch. In this case, let's stay with black. Be sure you have a full, juicy can for this step, and keep extra caps nearby, in case yours clogs up.

**1** Start your first letter a few inches to the left of the eye, so it appears to be shooting off from the eyelash.

**2** Control the distance between your cans and the wall when doing the outline. If you get really close, you'll get a thin crisp line, but you must work quickly. If you are a bit farther back you can work more slowly, but your line may not be as crisp. Experiment to see what works best for you.

**3** Change your line weight as you work the letters. This will involve going over some of your outlines in a wet-on-wet technique. When the *S* and *H* to the left of the eye look good, move on to the letters on the right side of the eye.

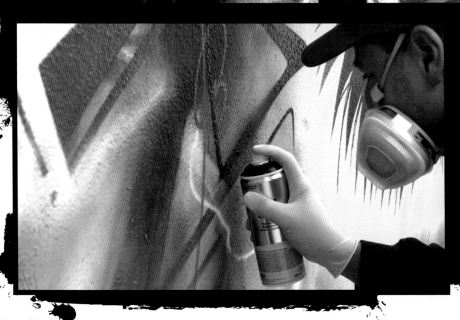

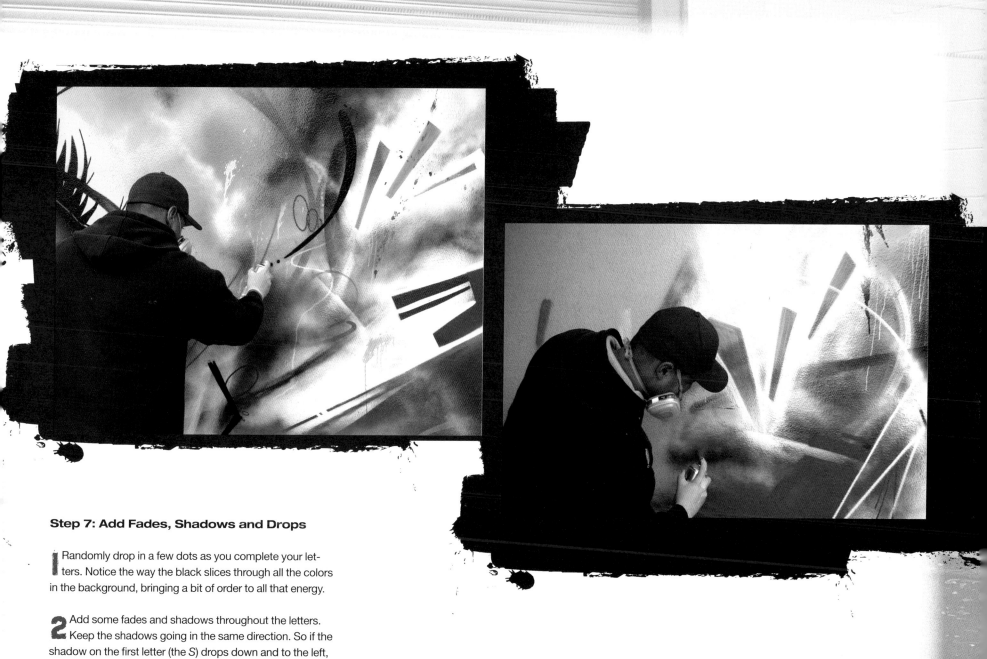

## Step 7: Add Fades, Shadows and Drops

**1** Randomly drop in a few dots as you complete your letters. Notice the way the black slices through all the colors in the background, bringing a bit of order to all that energy.

**2** Add some fades and shadows throughout the letters. Keep the shadows going in the same direction. So if the shadow on the first letter (the *S*) drops down and to the left, then it should drop down and to the left with every letter in the piece. Stay consistent.

Free downloads when you sign up for our newsletter at **IMPACT-books.com**.

81

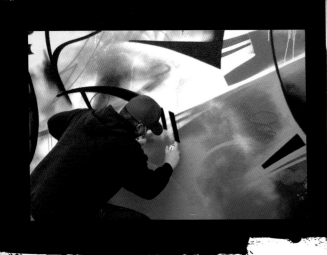

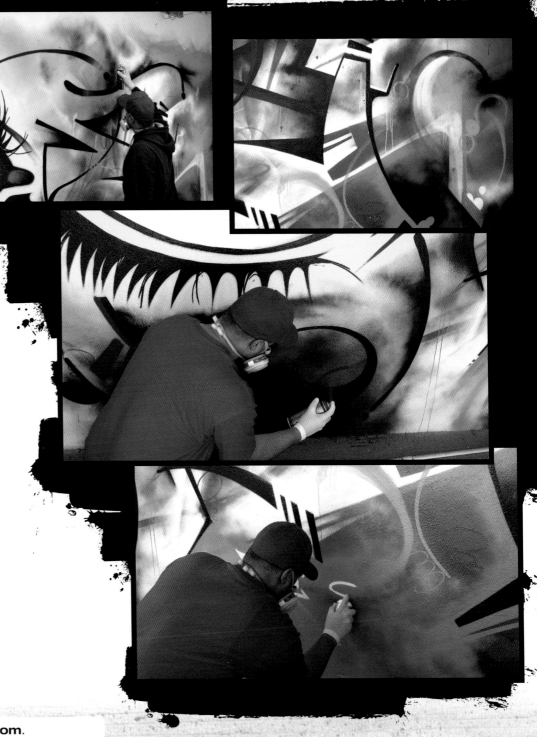

## Step 8: Add Final Details and Drop In Your Quote to Finish

You're nearly finished. It just needs a little something here and there to make it pop.

1 Use blue to cut out some of the portions around the bits. Shape up, cut out and cover whatever overspray you can to tighten up the outline and any other areas that stand out.

2 Fade in lime green, both outside and inside the letters. The idea is to bridge the gap between both spaces, so lay it over the outline creating a fog-like haze of color.

3 Place red on the edge of the *S* to frame that area. Add a strip of red to the *S* and to the *E*.

4 Fade turquoise into the curl beneath the eye. This adds a dark value to certain areas of the piece without having to use black.

5 Drop in your quote. The lime green expressions on the right are a great example of layering—it's faded, has expressive arcs, and some skinny cap action.

Get bonus material at **http://Graff2.impact-books.com**.

# You're Finished!

The letters take a back seat in this composition. Instead the emphasis is on colors and color choices. My hope is that this has challenged the way you view colors and their possibilities in graffiti.

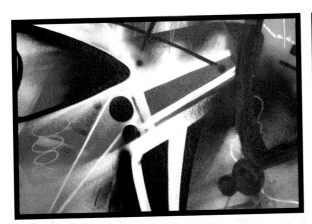
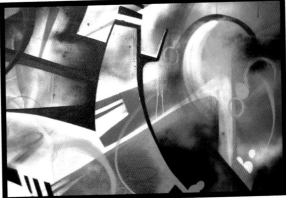
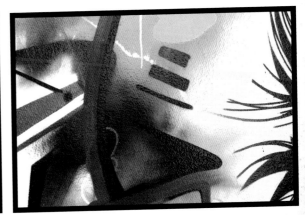

# THE POWER OF WILDSTYLE

Now we'll explore wildstyle lettering from a few different viewpoints.

Let's push the envelope a little bit by focusing not only on the letter patterns, but also on the color scheme. With abstract art ideas, we will use some color techniques that may be a bit different than you're used to. We'll also work a very different background, and bring all of these elements together for the grand finale.

Our wildstyle will extend into many areas. It will challenge your ideas as to what the rules are, and break a few right away. The focus is on channeling your expression and being able to "just do it." It's all an effort to explore ways of redefining old styles and creating new styles that can be as individual to you as your fingerprint.

This piece will read *POWER*. Remember though, wildstyle is designed to be indecipherable and difficult to read!

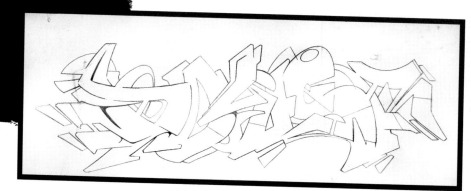

### Sketch

The focus is to capture the shape of the letters, their form, structure and style. We are going to explore colors in a wildly different way. These letters are just a framework for the colors and expressions that will fill in and go around the outlines. Let's uncork our creativity, and explore the power of wildstyle!

## PALETTE

black, blue, burgundy, dark blue, dark orange, dark purple, light blue, light orange, light purple, lime green, medium purple, orange, pink, red, turquoise, white, yellow

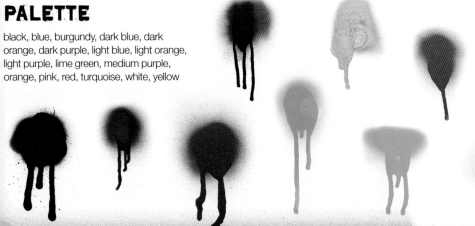

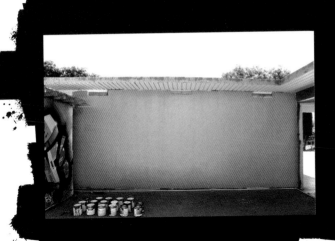

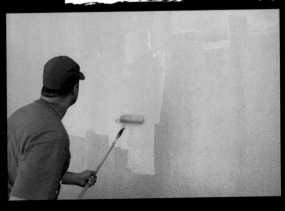

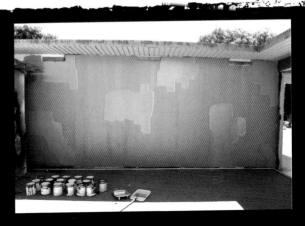

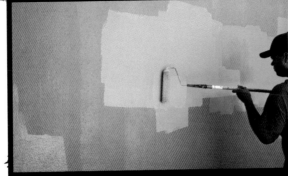

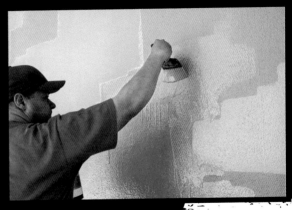

## Step 1: Start Your Background

Usually in wall prep you paint the wall a solid color and work with that. With this piece, we turn that notion on its head. I feel that graffiti art has strong elements of action painting attached to it. Here we'll take elements of action painting and get even more into the art, making it all the more personal.

**1** Begin with the base color, in this case pink. Visualize and think of which colors you can add to the pink to create a color composition. Think of movement, action and rhythm.

**2** Add a body of blue onto the wall in a very imprecise way with the roller, adding the color in random block areas. Blue is a good choice here because it contrasts with the pink and brings some tension and energy.

**3** Step back and look at the wall. Those blocks of blue add something to the composition. Now ask yourself what else you can add to the pink and blue as an in-between color.

**4** Lime green! Take your roller and, with random acts of creativity, add large bold blocks of lime green between the pink and blue. Take time deciding where to place the color. Walk back and forth along the wall to take it all in. Have fun with it!

**5** Add drips to begin creating a layered effect. The pink will appear to be on top of the blue, and the blue on top the green and vice versa. To get drips, take a paintbrush loaded with paint and apply it liberally on the wall.

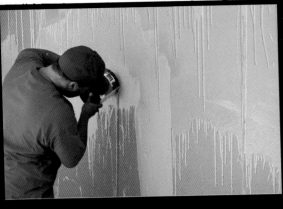
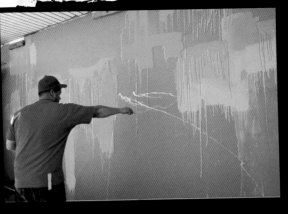
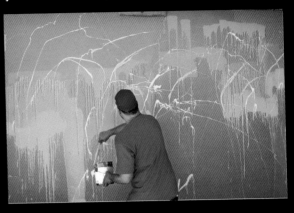
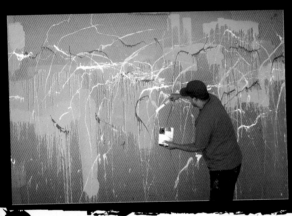
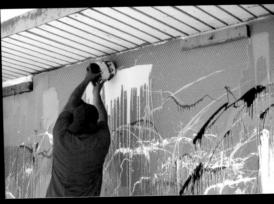
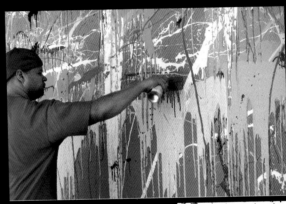

## Step 2: Splash Paint Effects to Complete the Background

Experimenting with different and new techniques allows you to open up your creativity and the way you express yourself.

**1** Leave the paintbrush and begin pouring paint directly out of the paint can onto the wall. This technique breaks away from traditional graffiti art.

**2** Hold a paint-stirring stick in your right hand and the can of yellow paint in your left hand. Yellow is a good choice because it complements the pink and contrasts with the blue. Strike out with your arm, letting the paint splash onto the wall. Though it may seem random, you can control the paint, the direction it spatters, and the way it lays on the wall.

**3** Repeat the same actions with light blue. You are building up a series of layers, so begin to think in terms of rhythm. Create a rhythmic motion going from left to right across the wall. Work to create a spider web of colors and rhythm.

**4** Add splashes of red and white. At this point you can work quickly, aggressively and confidently. Scan the wall as well as your palette of paint. Reach for the colors that strike you as needed at that moment. Reach and splash.

**5** Pour the can of yellow down the wall. The pinks, blues and yellows all combine to create a whole new kind of background for you to work your graff art on.

**6** Add some deliberately random strokes and drips with burgundy spray paint.

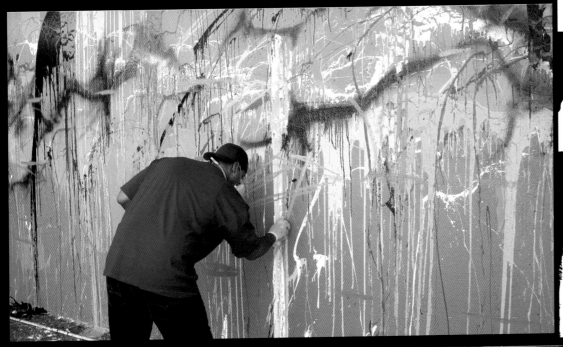

## Step 3: Do Your Sketch

After all of this activity you may find yourself exhausted. But it is important you stay focused when doing the sketch, because with all the activity going on in the background it's easy to get lost in the maze of colors and spray marks. Take your time and remain focused.

**1** Using some spray paint, lay horizontal marks across the wall. Place a few knee high, a few chest high, and a few waist high. This will help you lay out the letters.

**2** Keep your sketch nearby and use it for reference. Working from left to right, pace yourself and lay out the sketch in an orderly fashion.

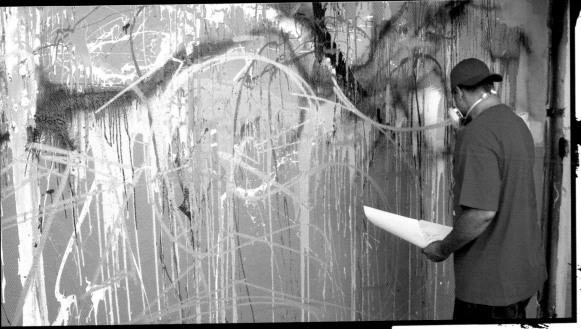

Free downloads when you sign up for our newsletter at **IMPACT-books.com**.

87

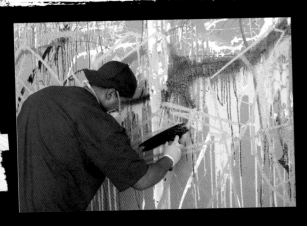
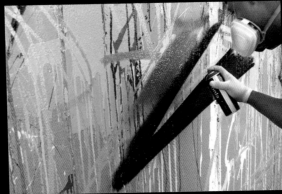
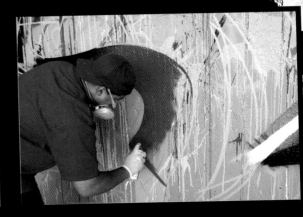

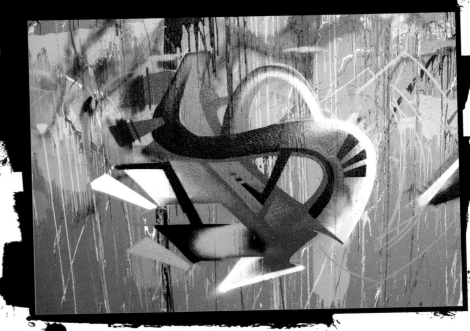

## Step 4: Do Your Fill-Ins

When doing the fill-ins, keep your palette in mind. The color scheme should go from black to purple to white in a series of gradient fades. Cut and slice the colors all the way through. Make the *O* and the *E* different color schemes as well. This will keep the viewer off balance, while balancing the piece itself.

**1** Start in the center of the *W* and work your way around it with black. Keep your strokes tight and precise, spraying over the background and keeping your spray patterns opaque.

**2** Introduce two shades of purple, dark and medium. Both work well with black, but the focus is on creating a gradient pattern inside the letters.

**3** Move over to the letter *P*, continuing with the gradient pattern. From medium purple, go into light purple and then into white. From the white, drop in a little splash of yellow.

**4** Step back. Keep in mind that you want to go from black to white, but have the gradient run through shades of purple. You're using the black and white as colors and integral parts of your fill-ins, not simply as shines or accents. Using white also helps to introduce the yellow.

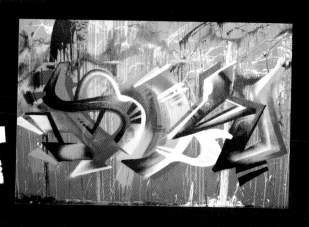

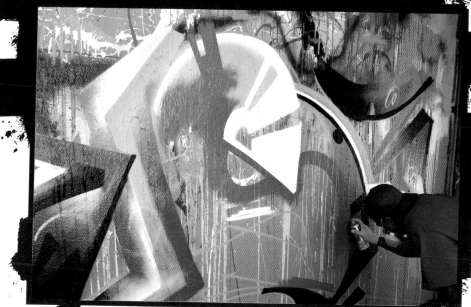

**5** For the letter *O*, the palette is based on warm oranges and yellows. Lay down some bold strokes of orange to make the letter stand out from the rest of the piece.

**6** In working the orange, begin adding darker values. Go with deep burgundy, blend into a lighter orange, and then blend that into the darker orange. Cut back and forth and add bits into the color patterns as you go.

**7** Step back and look at your work. Notice how the various colors work with each other. Have the orange rub up against the purple, but also bring in some white along the right edge of the *O*. This ties it together with the rest of the letters.

**8** Using what you've just done as a guide, begin working on the letter *E*. Start with white and trace out a portion of the letter. Then add some light blue. Cut out the letter, shape it, and cut out the color forms as you go. The white should end up shaping the right side of the letter, while the blue shapes the rest of the letter. The light blue appears to slice into the white, but this effect is actually done by having the white slice into the blue.

Free downloads when you sign up for our newsletter at **IMPACT-books.com**.

89

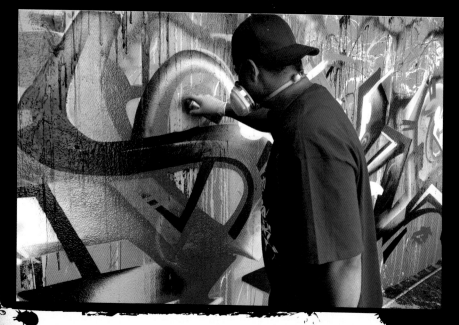

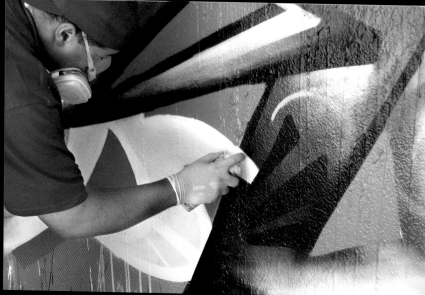

## Step 5: Work Out the Details

There is a lot of activity happening on the wall right now. Bring a bit of calm to the work by filling in the blanks, so to speak. Use a solid color to fill in any open areas between the letters and areas of negative space, such as in the *P*.

**1** Begin with turquoise. Starting in the upper left area and working left to right, fill in the empty areas. Get as close as possible to the edges of the letters and clean up wherever needed.

**2** Continue to clean up as you go, retracing the edges of the letters in white. This will give a crisp edge and get you ready for the final outline.

**3** Add some black dots. Run through the piece and slice, cut and tighten up all black areas.

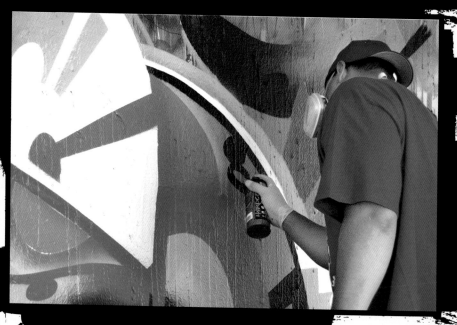

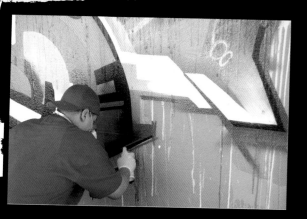

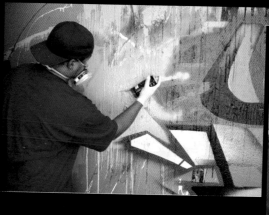

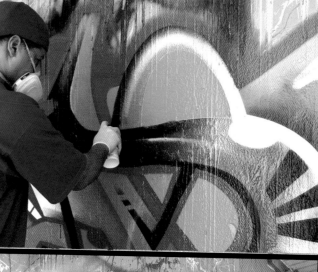

## Step 6: Outline the Piece

We've been composing this piece in a rather unorthodox way. To continue in that manner, wrap the piece in red and take steps to tie the letters into the background.

**1** Begin on the lower far right side. Drop in some crisp red lines and allow them to run off and into the background. This will create an almost cubist effect as you break up the background.

**2** Continue working the red around the letters. When you get to the left side, drop in the lime green. This lime green will pair up nicely with the lime green you used when setting up the background.

**3** Here you'll do the heavy lifting. Outline the inner portions of the letters. Take your time, focus, and keep your lines crisp and clean. Change your line weight as you outline.

**4** While outlining, simultaneously add extra fades and colors to the edges in an effort to fold the letters into the background.

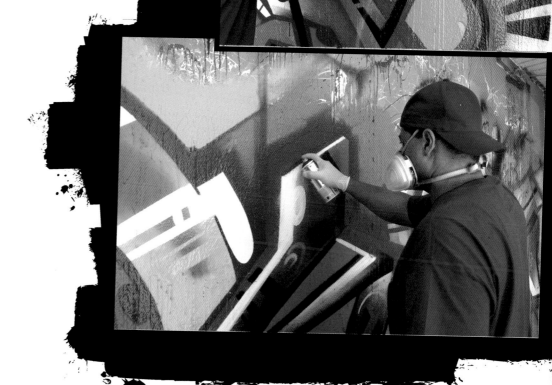

Free downloads when you sign up for our newsletter at **IMPACT-books.com**.

91

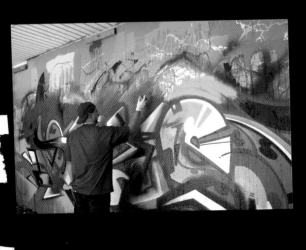
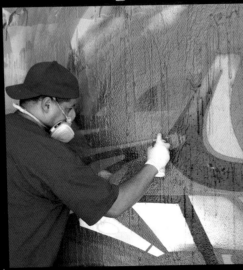
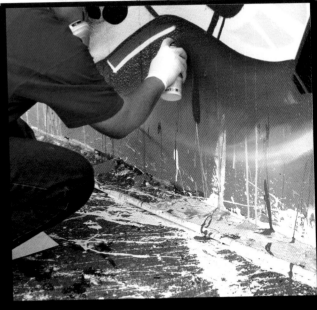

## Step 7: Add Details and Finish

You are now racing towards the finish line, and the challenge is to bring the letters more in tune with the background. The background is abstract and full of rhythm, splashes and drips. Bring it all together with a few creative twists.

1 Continue adding red to the upper area behind the letters and fade it out. Using diagonal strokes, fold it into the various nooks of drips and splatters. You can also use red to add bubbles inside the turquoise areas.

2 Add bits of true blue to the piece. In this case, lay them on top of the piece, overlapping the letters, outline and background to help bring the various style elements together.

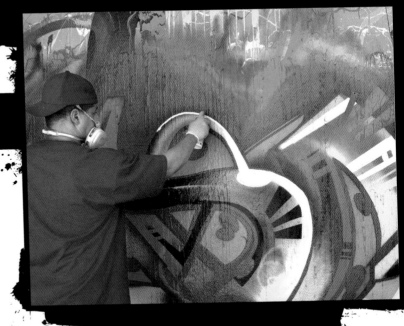

3 Add in some red drips; these should be drawn, not splattered. This provides a contrast between the two styles of drip techniques. Add an arc of yellow and white, shooting from inside the letters into the background.

4 Do a classic shine on the right edge of the letters. Add three floating blue bits on the right, not inside the letters as the black is, but floating on top. This is a great example of how to add elements that tie your composition together.

Get bonus material at **http://Graff2.impact-books.com**.

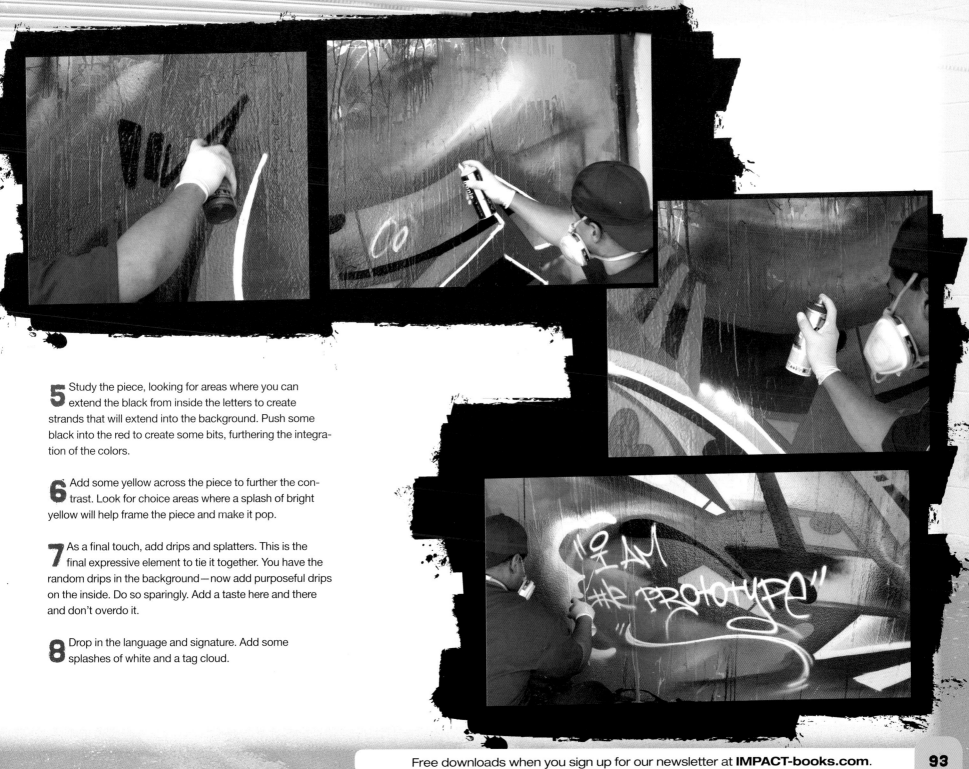

**5** Study the piece, looking for areas where you can extend the black from inside the letters to create strands that will extend into the background. Push some black into the red to create some bits, furthering the integration of the colors.

**6** Add some yellow across the piece to further the contrast. Look for choice areas where a splash of bright yellow will help frame the piece and make it pop.

**7** As a final touch, add drips and splatters. This is the final expressive element to tie it together. You have the random drips in the background—now add purposeful drips on the inside. Do so sparingly. Add a taste here and there and don't overdo it.

**8** Drop in the language and signature. Add some splashes of white and a tag cloud.

## Mission Accomplished!

Give yourself a major pat on the back. You have channeled your inner abstract expressionist and hopefully opened up some new channels for your creativity. You have most certainly used many style elements and techniques. Now, how can you build on these to create new styles that are reflective of you and your personality?

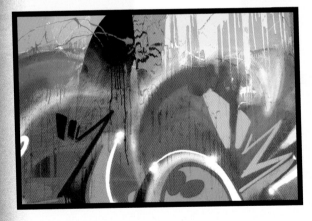

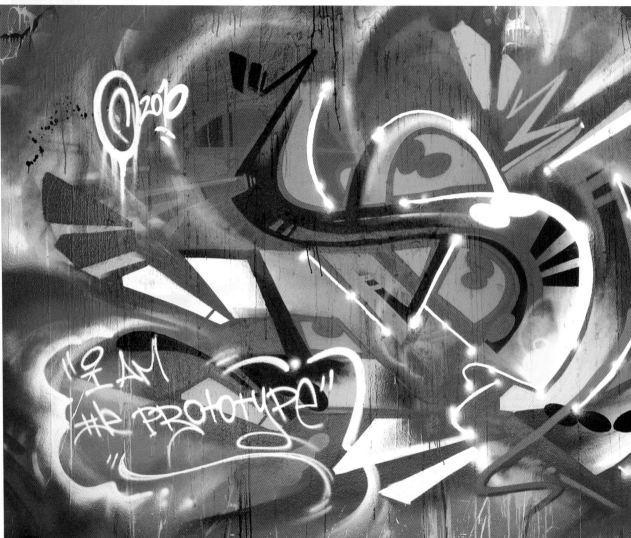

### POWER

*I am the prototype, not the stereotype.*

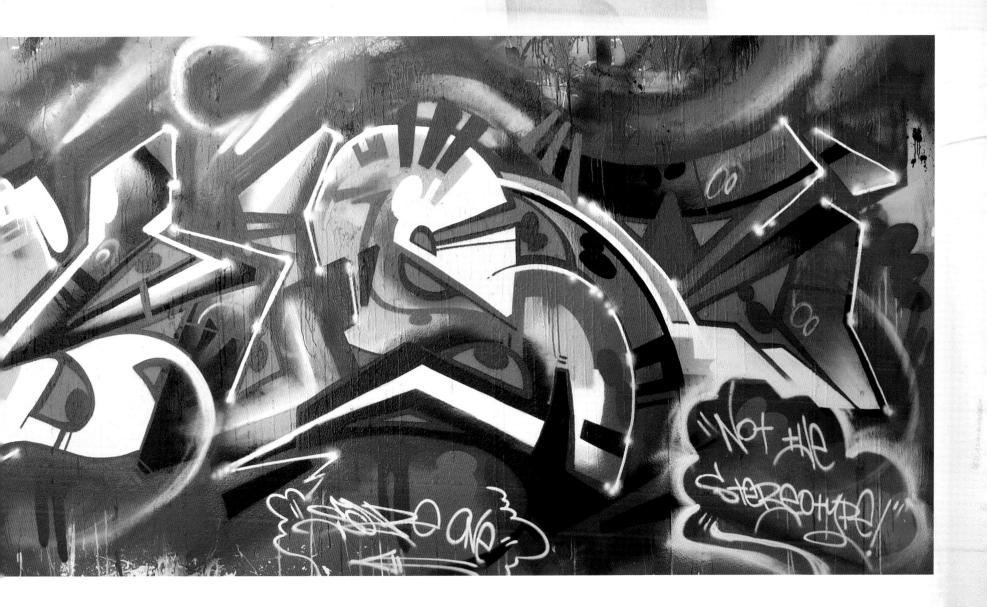

## Working on Walls: Double Vision

# A NEW STYLE OF PIECING

*Peace* and *piece*. Phonetically the words sound the same, but they have drastically different meanings. We will take that idea and add a twist to it, using the double vision style.

In this case, when our double vision composition is finished, it will read *Peace* going from left to right. But view the image in reverse, and it will read as *Maker*. So the message is *Peace Maker*, but phonetically it also sounds like *Piece Maker*.

In doing this piece, many of the steps may seem to you to be out of order or counter intuitive, but it will all come together in the end. It's all a part of the learning process. Just follow along and remember that you are the Piece Maker.

### FREE BONUS DEMO!

Check out Scape's demo on how to prep a wall at http://Graff2.impact-books.com

### Sketch

The sketch, raw here. Use pencil without any extra outlines or colors so that you can fill in the blanks on the wall. This time we will explore color patterns a little differently.

## PALETTE

black, bright blue, burgundy, gray, jungle green, light blue, light green, light turquoise, orange, pink, true blue, turquoise, white, yellow

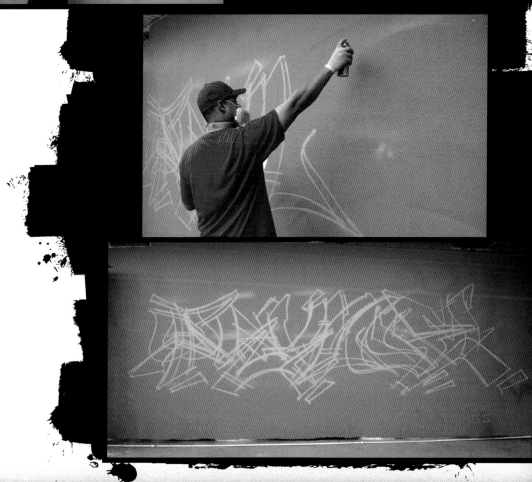

## Step One: Prep the Wall and Do Your Sketch

**1** Your blank canvas is an orange wall. You can still see the ghost pattern of what was underneath the orange, and that's OK. When painting over existing work, it is not essential that you completely cover the previous piece with an opaque layer of color.

**2** Lay three quick sketch marks along the wall at various heights—one with your arm extended shoulder high, the other just above your head, and the third around waist high. Use a color that will contrast against the orange.

**3** Using the previous markings as a guide, begin your first sketch. Make clear lines and slowly draw out your piece.

**4** When you begin to get into the higher areas, you will lose a lot of can control. If you want detail in those high places, get a ladder.

**5** Step back and check your work. To the untrained eye this may appear as scribbled gibberish, but you are the artist and know better. Since you have an idea what your color patterns are going to look like, there is no need for a second sketch.

Free downloads when you sign up for our newsletter at **IMPACT-books.com**.

97

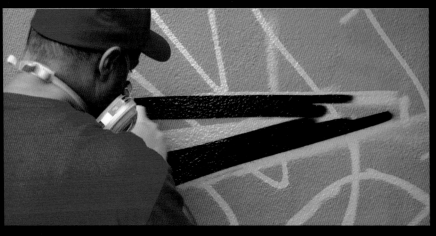

## Step Two: Begin Your Fill-Ins

Remember, black is a color in graffiti art. Many graff artists shy away from using black because of the challenges it presents, but there are ways to make it work.

**1** Begin to drop in black—this will be your primary fill-in color. In deliberate painterly strokes, cover everything underneath and create an opaque base from which to work.

**2** Take a quick step back to check your progress. Make sure the edges are as crisp as possible and that your fills are solid. As you continue, keep your pencil sketch handy and clear up those sketchy areas.

**3** Cut through all the miscellaneous lines and continue dropping in black. When laying down a flat color base like this, bounce around the letters, painting them in different orders and bringing it all together in the end.

**4** Take another step back and view your work. All the lines should be covered up, leaving the basic black framework to work with.

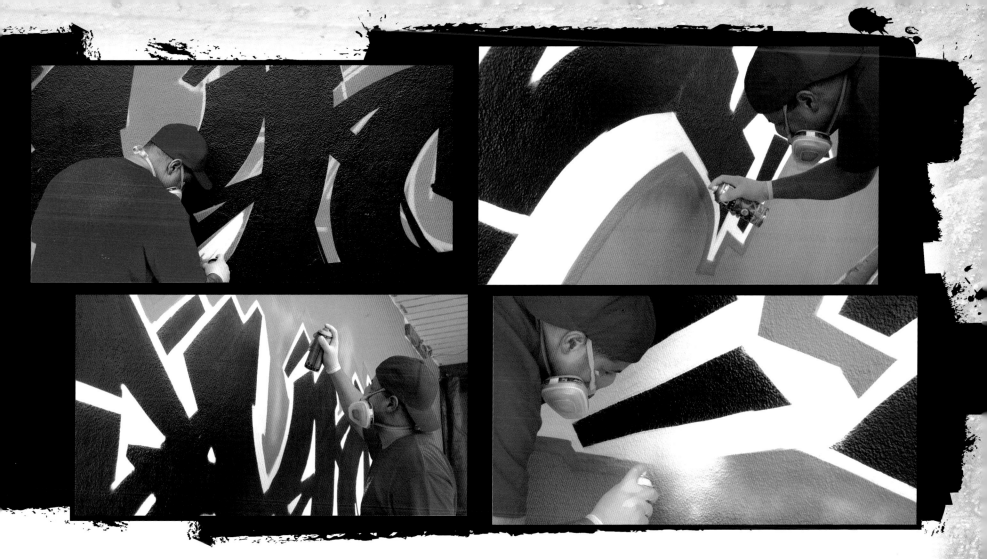

## Step Three: Work the 3-D

In this stage your focus will be on the 3-D and the immediate glows in the surrounding area.

1 Begin doing the 3-D with white. You didn't draw in the 3-D when doing the wall sketch previously because you already knew that the primary colors would be solid black and white. It's easy enough to drop in the 3-D without having to sketch it first. Cover any remaining unwanted sketch lines and tighten any overspray from the black.

2 Go in with jungle green and retrace your letters. Go around the edges and trim the letter composition with the green, using it to fill in any open gaps inside the letters as well.

Locate bays, areas where portions of the letters jut out creating spaces or nooks, and drop in some fades in those areas.

3 When finished with the green glow, add in a lighter green. This adds depth as you gently lay in a little bit of lighter green and fade that into the orange background.

4 After the green, go back in with some white. Go into your 3-D and clean up any overspray. Make some areas as crisp as you can, and add fade outs to others.

Free downloads when you sign up for our newsletter at **IMPACT-books.com**.

99

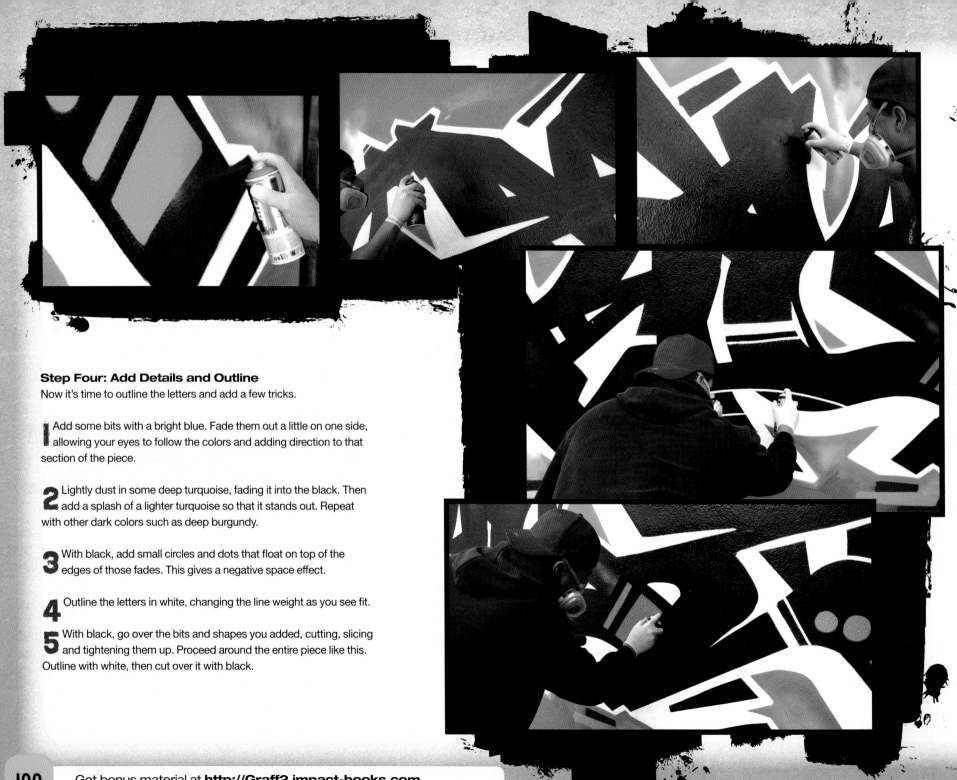

## Step Four: Add Details and Outline

Now it's time to outline the letters and add a few tricks.

**1** Add some bits with a bright blue. Fade them out a little on one side, allowing your eyes to follow the colors and adding direction to that section of the piece.

**2** Lightly dust in some deep turquoise, fading it into the black. Then add a splash of a lighter turquoise so that it stands out. Repeat with other dark colors such as deep burgundy.

**3** With black, add small circles and dots that float on top of the edges of those fades. This gives a negative space effect.

**4** Outline the letters in white, changing the line weight as you see fit.

**5** With black, go over the bits and shapes you added, cutting, slicing and tightening them up. Proceed around the entire piece like this. Outline with white, then cut over it with black.

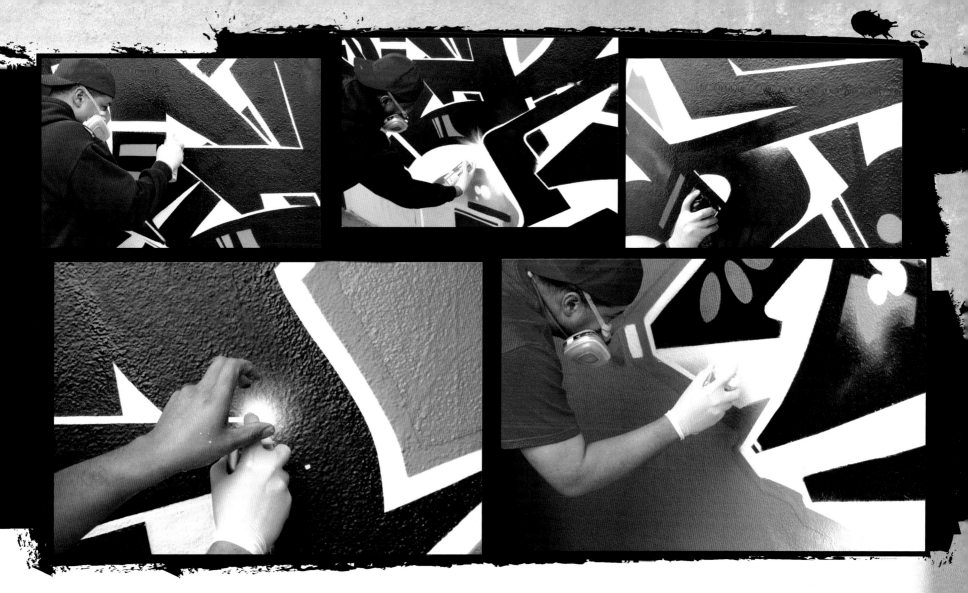

**6** Go back in with white and straighten your lines. Take your time and concentrate. Take frequent breaks so you can keep your focus.

**7** Use the white to drop in some shadows. Look for areas where the letters overlap and add shading. The shadows then look like shines.

**8** Continuing with the shadows, counter again with black. Look over the letters for areas where you can add a dusting of black to smooth out those shadows.

**9** Add some traditional shines. Hold your spray can in your hand and lightly tap the cap until you get a light snap of color.

**10** Drop in some graphics on the edges of your 3-D using gray and white. Don't add full details and heavy graphics—just go light and keep the focus on the white.

Free downloads when you sign up for our newsletter at **IMPACT-books.com**.

101

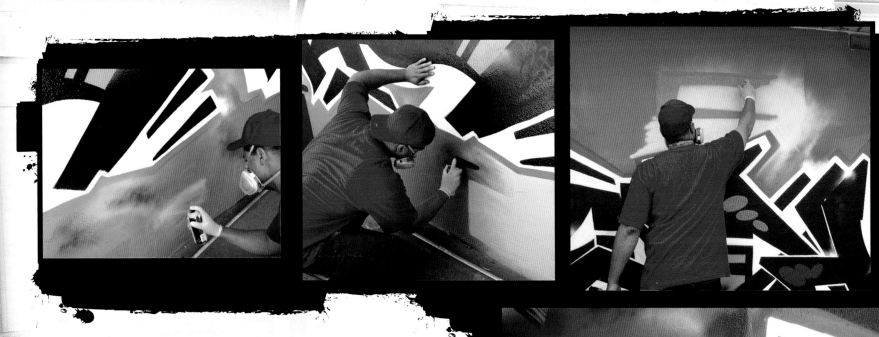

## Step Five: Work the Background

The letters are only a portion of your statement. The background is the rest. We're going to do a background that is a bit different from what we have done before—large areas of bold colors and few fades.

**1** After viewing the piece from a distance, map out in your mind where you can place some large blocks of color. You want a collage of colors, large rectangles and squares in vibrant colors that contrast with each other to make the wall vibrate. Start at the bottom and begin dropping in yellow.

**2** Add a deep burgundy, dropping in the shapes, pieces and bits where they will be the most effective. When laying in the colors at first, you do not need to make the edges perfect.

**3** Go over some of the yellow with a vibrant blue.

**4** Go over some of the orange on the left side using a vibrant turquoise. Blend some of the color into the edges of the letters.

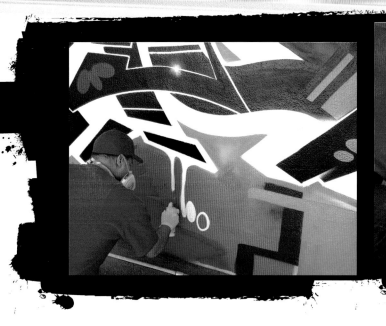

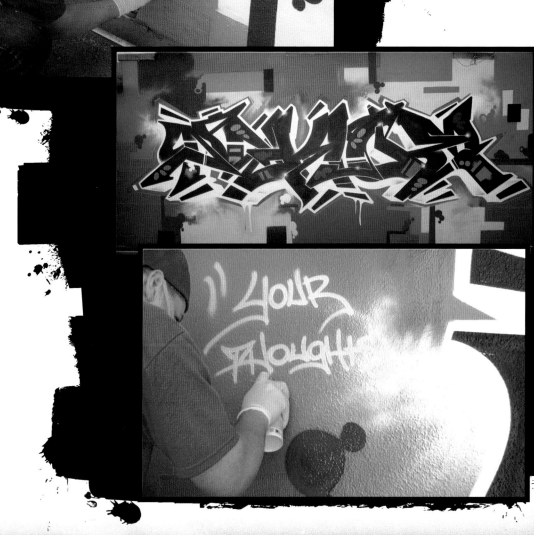

**5** Using a true blue, go over the orange at the base and begin to block it out. Use a skinny cap and the cutting technique to do the edges and get them crisp.

**6** Go around the background cutting and tightening where needed. Feel free to drop in some dots and bubbles, but do so sporadically. Keep the focus on the hard edges.

**7** Back up and see where you're at. The letters are complete, the background is done, but the quotes are missing.

**8** Use a different color for each line of quotation. In the turquoise area, use a yellow. For the orange section, use turquoise. And for the yellow section, write with a deep blue.

Free downloads when you sign up for our newsletter at **IMPACT**-books.com.

103

## Your Piece Is Complete!

You have finished your *Peace* piece. Take a photo, hold it up to a mirror and look at in reverse. It also reads *Maker*!

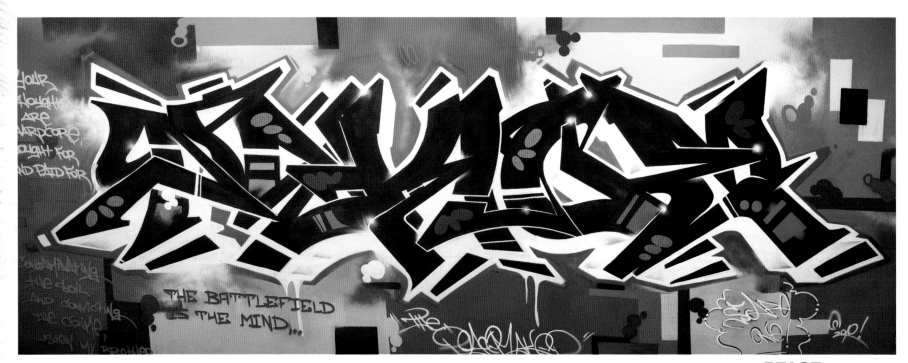

**PEACE**

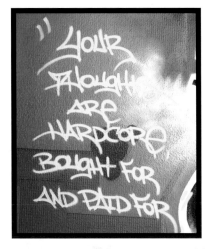

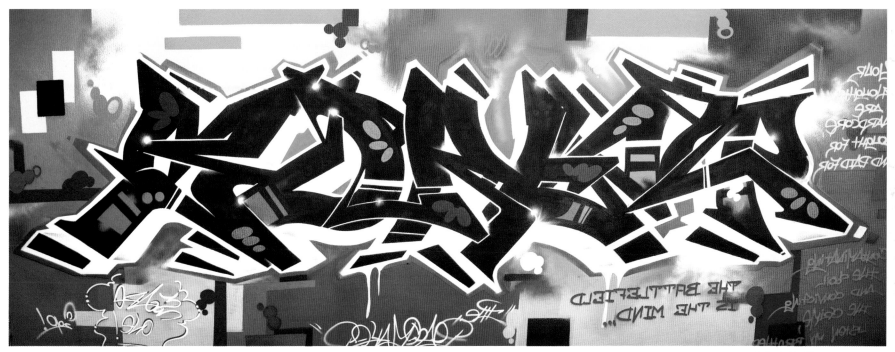

MAKER

Free downloads when you sign up for our newsletter at **IMPACT-books.com**.

105

# WATCH THE AWESOME BLOSSOM

When showing your graffiti art, you can get various reactions from people, some good, others not so good. But when you put your heart and soul into it, it shows, and that energy, that skill, that power can erupt right off of the wall. At those times, the reaction can be captured in a single word and that word is *Awesome*.

Take some time to reflect on and play around with that word. See where the letters take you. How can you manipulate the letters to convey the message you want to send? And what about the colors? You'll want to do something that reflects the word the right way.

This will be a wildstyle piece with a character, a color square, a tag cloud, the works. It will be a burner, a complete statement of styles and meaning. As you work your way through the piece, keep in mind the open and improvisational aspects of everything you're doing. You will have a plan, but you will also be working off of your creative instincts. Let the spray can become the extension of your imagination. As you continue to practice and grow, it will become a tool for you no different than an ink pen. When that happens, it is truly awesome.

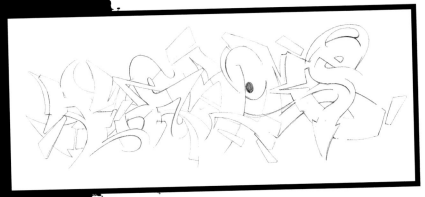

### Sketch

This pencil sketch is a great example of *open letters* done in wildstyle. Open letters are when the outlines don't connect all the way around so the letters are essentially left open.

## PALETTE

blue, burgundy, dark blue, dark green, deep purple, deep turquoise, green, lavender, light blue, light gray, light green, light pink, light turquoise, medium blue, medium gray, medium green, orange, pink, red, white, yellow

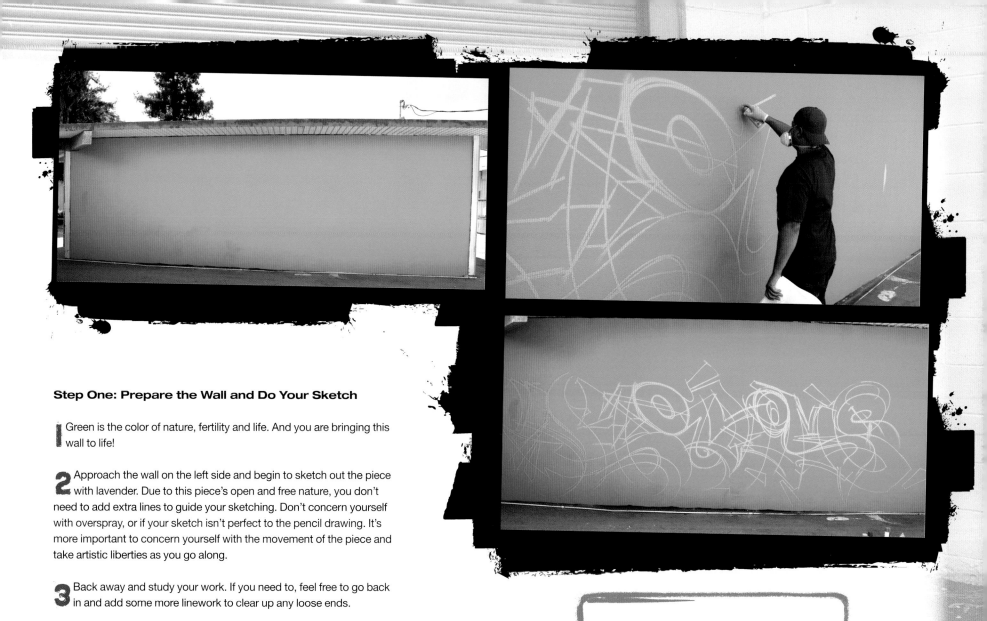

## Step One: Prepare the Wall and Do Your Sketch

**1** Green is the color of nature, fertility and life. And you are bringing this wall to life!

**2** Approach the wall on the left side and begin to sketch out the piece with lavender. Due to this piece's open and free nature, you don't need to add extra lines to guide your sketching. Don't concern yourself with overspray, or if your sketch isn't perfect to the pencil drawing. It's more important to concern yourself with the movement of the piece and take artistic liberties as you go along.

**3** Back away and study your work. If you need to, feel free to go back in and add some more linework to clear up any loose ends.

### FREE BONUS DEMO!

Check out Scape's demo on how to prep a wall at http://Graff2.impact-books.com

Free downloads when you sign up for our newsletter at **IMPACT-books.com**.

**107**

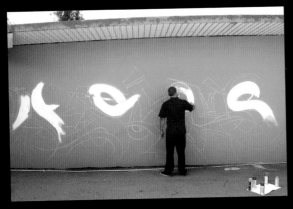
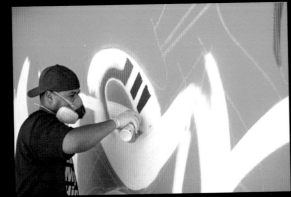
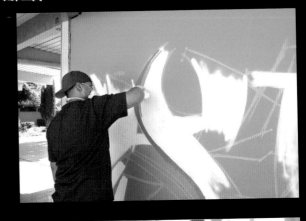
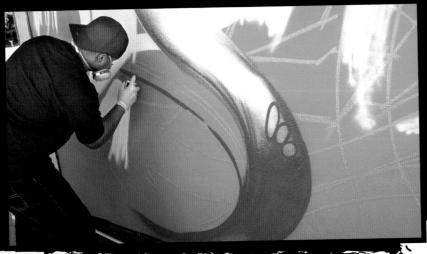

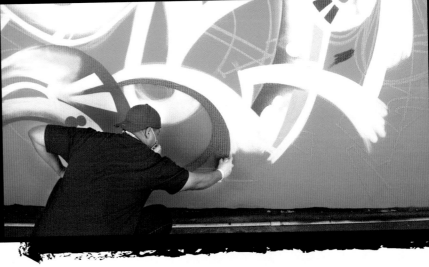

## Step Two: Begin the Fill-Ins

**1** The primary color for the fill-in is white. White can blend with any other color, but over-spray is very noticeable. Keep that in mind as you work. Drop in a white base in every other letter. Work in a random fashion.

**2** After viewing the work from a distance, add a few colorful bits and details. Curve pink around the inside of some of the letters and fade it into the white. Add floating red bits over the white.

**3** Go back to the first letter and drop in two shades of gray. Go from white to a light gray and then into a medium gray. Tighten up the letters as you continue to add color.

Continue in this fashion, snaking your way through the letters. Work the white, then add the grays, fade them in, and then back to white. Stay horizontal with your movements, using the shape of the letters to inform the movement of the paint.

**4** Working the lower end of the first letter, drop in two shades of blue. Your fades should go from white into gray, and white into the gradient blue. Make sure the white is opaque. Snake your way through, making the white opaque and playing between the blues, fading both together and in turn fading it all out into the green of the base. Cut and reshape the letters as you go. Drop in dots and bubbles where you see fit.

**5** Add a pink arch to balance the letters, and continue adding more red bits as needed. Notice the way the color palette has developed. White is the foundation, balanced by warm and cool colors.

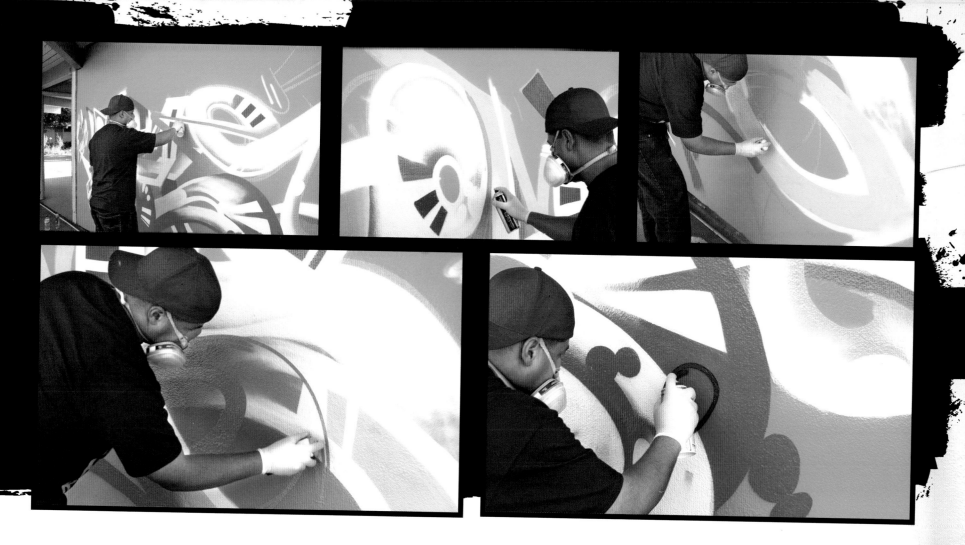

## Step Three: Continue Fill-Ins and Add Accents

**1** Go back to the *E*. Slice through the letters with a true blue bar, and slice in some white.

**2** Fill in the far right of the piece with light blue and a tracing of white. Keep it tight and close to the edges of the original outline.

**3** Take your true blue and retrace the shape of some of the letters. Go along the right edge of the *O*, making that pop out a bit. Walk around the piece and tighten up where needed.

**4** With the same blue, work the large swirly arrow on the lower right. You will paint over some other portions of the letters and this is OK, because it actually makes your work tighter.

**5** Go around the piece and do some detail work. Drop in some red dots. Feel free to add more dots, bubbles and accents.

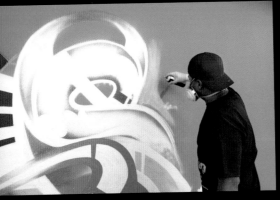
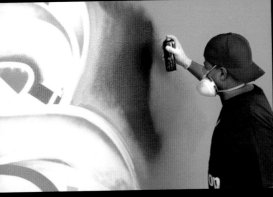

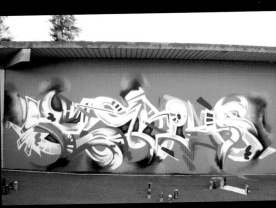

## Step Four: Begin the Background

The main purpose of the background is to tie all the elements of the piece together and pull it back to the wall. When choosing the color for the background base, pick a color that you can pair up with the equal in spray paint. It makes for great blending and saves you time and energy.

**1** Drop in yellow to the left and right of the piece. Stay close to the edge of the letters and fade outward in a radial fashion.

**2** Fade in a gradient effect from orange to red to deep burgundy.

**3** Lay in some deep turquoise where all the open sections are, that is, where the letters are not going to be outlined and where you want the fill-ins to bleed into the background.

**4** With a light turquoise, fade from dark to light and go into the green background.

**5** Begin to work the nooks, the empty spaces inside the letters. Start with turquoise and go from dark to light, with black on the edge to give it a sense of depth. Be careful not to add too much of the light turquoise. Just drop in a splash of color in the center of the nook.

**6** Take a few steps back and look at the entire piece. Do you see anywhere that needs attention? Any places that need to be filled in, any details that can be worked on? Take mental notes and keep working.

Get bonus material at **http://Graff2.impact-books.com**.

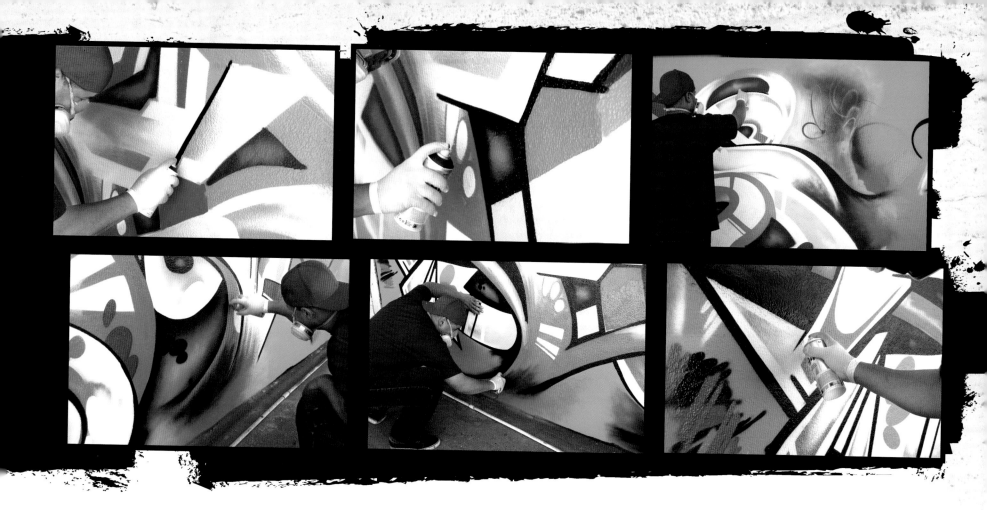

## Step Five: Outline and Add Details

The outline is the single most important part of this piece, so rest before you start working it. Your finger should not be fatigued, and you should be relaxed, clear-minded and focused.

**1** Your outline color is black. Start with outlining the bits, but feel free to jump around as you go. Do the easiest parts first, or you might want to do the stuff that is most accessible to you, like the lower portions of the letters. Change your line weight as you go.

**2** Add some fades to the nooks. Take advantage of your inspiration as it strikes you in the moment and add additional black shadows and shading as you move along.

**3** With black, create a cascade effect off of the *E* so that it flows into the background.

**4** Go back to the pink arc and add a more powerful stroke. Keep the curve clean and crisp to make it pop.

**5** Rework the open areas. The black outline should go from crisp to a fade. Increase the line weight as the outline gets closer to the open areas.

**6** Go around with white and tighten up the piece. Look for any overspray, crooked lines or anything that looks less than crisp. Once you are done with white, repeat the process with your other colors. You're going to find little mistakes. Now is the time to fix them.

Free downloads when you sign up for our newsletter at **IMPACT-books.com**.

III

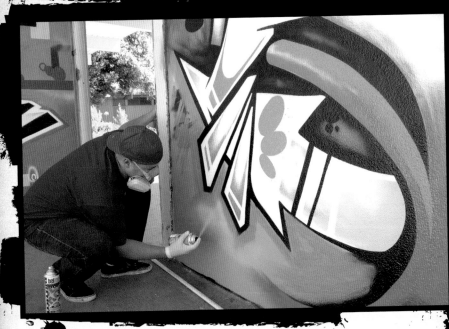

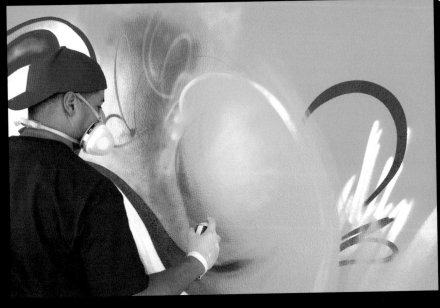

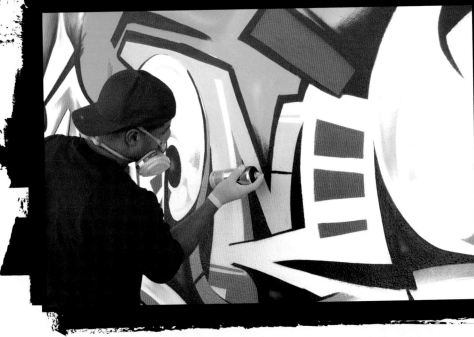

## Step Six: Work the Background

Even though this background is a series of fades and gradients, keep your fading clean and gradual. This is a study in subtleness, whereas your letters are a study in controlled chaos. Strike a balance in the middle.

**1** Start with three values of green. The goal is two-fold: fade the open areas of the letters into the green, then fade the green into the background. Add yellow for some extra flavor, continuing with the depth perception.

**2** Go with the flow of the cascading *E* and create a swirl-like cloud pattern with green on the edges and yellow in the center to create depth.

**3** Add fades on the outside of the letters with black. Carefully tilt the can at a hard angle and gently fade the black from the outline away from the letters and into the green.

**4** Make the piece really pop. Add some glows in bright red.

**5** Step back and check your progress. Go back in and add small details or fix things at this point. Once that's finished, you are free to move on to the next stage of the burner.

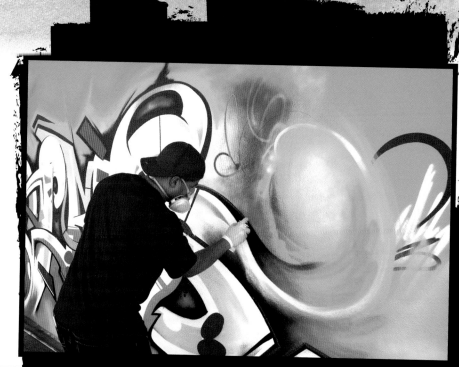

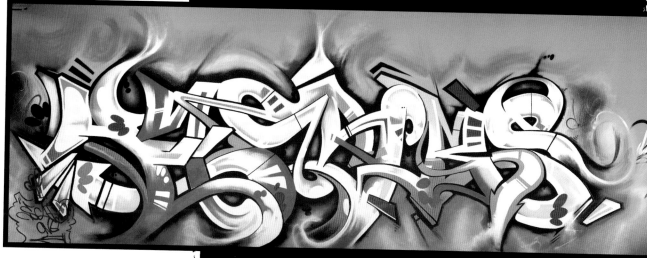

Free downloads when you sign up for our newsletter at **IMPACT-books.com**.

113

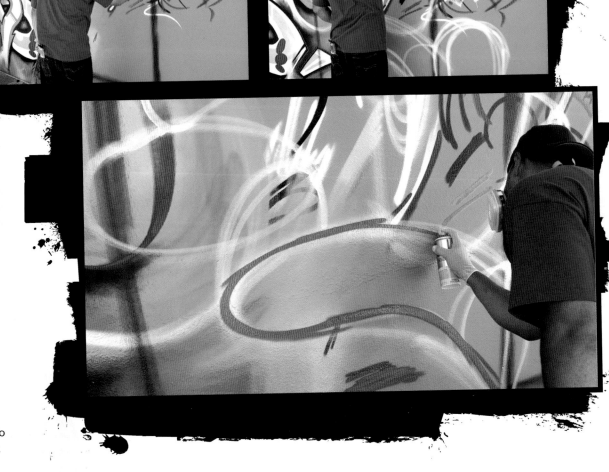

## Step Seven: Sketch the Character

**1** Create a pencil sketch for the character. Incorporate the style element of the color square, so it appears that the character is leaping out of one thing and into something else. Explore creating metallic surfaces and shadow techniques when sketching.

**2** Sketch out a loose, giant square to the right of the letters. Don't spend a lot of energy trying to make it perfect; you'll be able to tighten it up later.

**3** Use white to sketch the character by drawing in ovals, spheres and tubes. The arms are tubes, the body an oval, and the legs are tubes.

**4** With orange, go over the loose sketch lines you want to keep. Focus on movement and clarity of the character.

Get bonus material at **http://Graff2.impact-books.com**.

## Step Eight: Begin the Fill-Ins

When doing your fill-ins, remember that whatever works for the letters works for the characters—shading, gradients, cutting, slicing, etc.

**1** Fill in the legs with light blue. Keep the colors as close to the edge as you can so that only a thin strip of orange is apparent. Continue filling in the rest of the character in this fashion.

**2** Fill in the color square. Build a gradient with white and fade into lavender and then deep purple along the edge. This will add to the illusion of the color square.

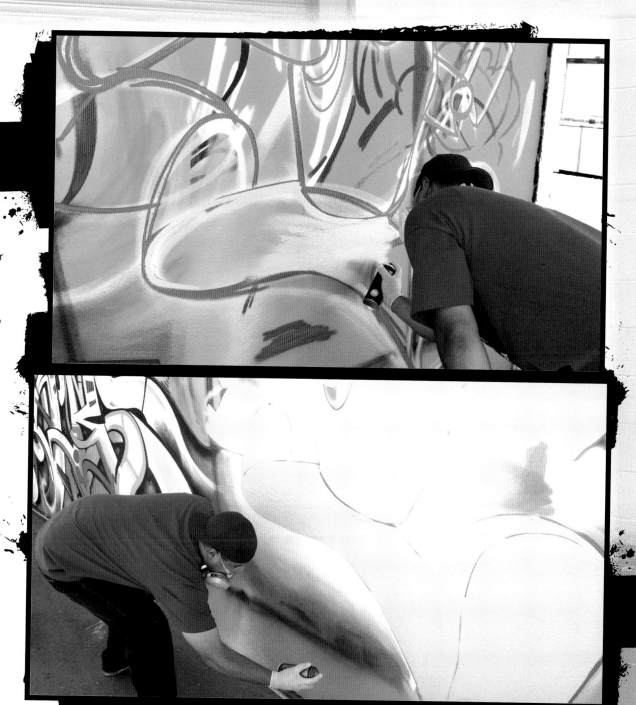

Free downloads when you sign up for our newsletter at **IMPACT-books.com**.

115

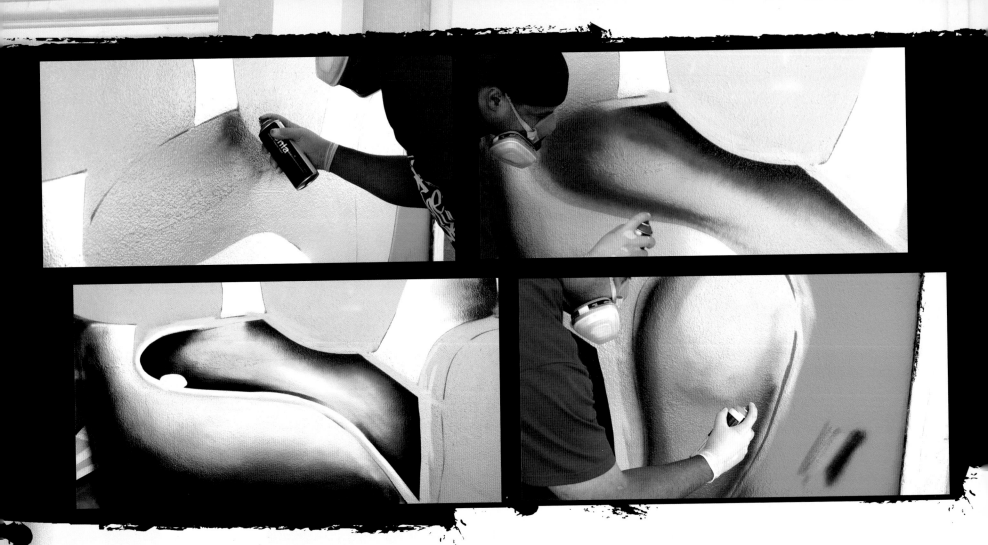

## Step Nine: Add Graphics

When dropping your graphic elements into the character, take your time and keep your hand steady. It's a satirical image, so you don't want a photorealistic style, you want something more stylistic and open to interpretation.

**1** With a darker blue, gently add shadows around the waistline of the character. Fade away from the body and into the movement in the legs.

**2** Continue with blue and carefully wrap around the leg. Add black and white to create a gradient fade. This will give the illusion of a metallic surface.

**3** At the waistline, use a dark blue, faded into a medium blue. Add some white trim along the left edge. Add black for a shadow effect where the leg connects to the right foot.

**4** Still working on the foot, use slivers of orange as a guide and recreate the blue fade you did earlier. But in this area don't add any black. Work from dark to light, then again from light to dark, sprinkling in a little white along the tip of the foot.

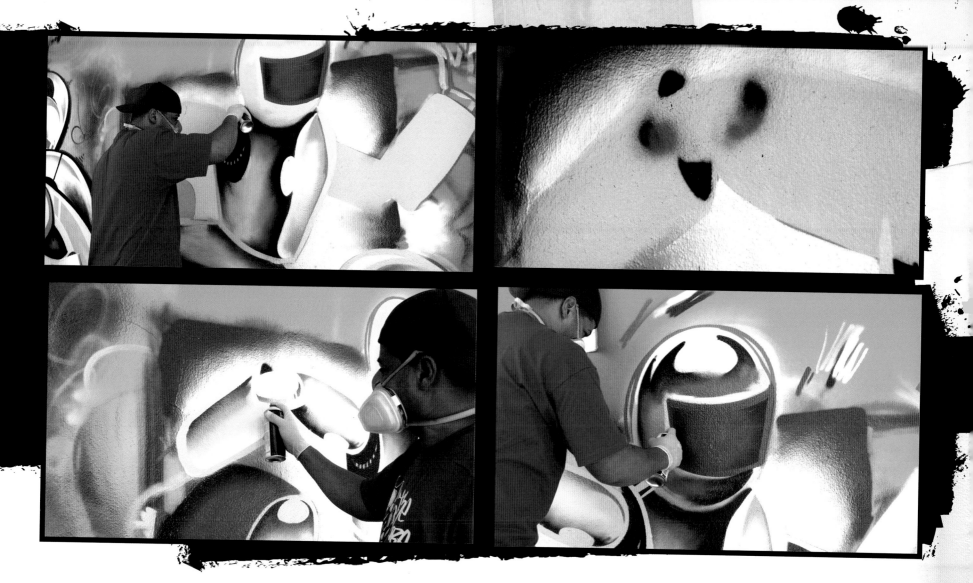

**5** Using black, trace the neck area and the shoulder opening. These illusions are based on a few shades of blue, along with black and white. That is how you create a reflective surface.

**6** Add a few splashes of color to the elbow area—medium blue, dark blue and black on top. Then go in and cut out an oval shape with your light blue to create an elbow joint.

**7** Using the same methods of shading and cutting, go through the rest of the character, filling in and shading. Use the light blue the way you would use an eraser on paper. Going from dark to light on one side, then light to dark on the other, creates a tubular appearance.

**8** Slowly and carefully add the blues and fades to the head. The focal point should be the very top of the head. Create an almost marble-like appearance.

Free downloads when you sign up for our newsletter at **IMPACT-books.com**.

117

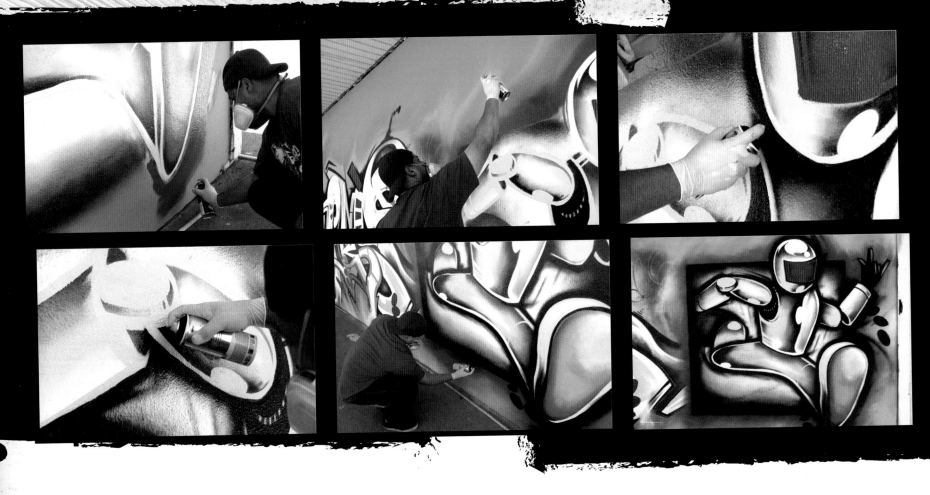

## Step Ten: Work the Background and Outline the Character

As with the letters, the outline will be the one of the most important parts of your character, and the background will be the visual bridge connecting the character to the rest of the piece. This is where you realize the vision, from paper to the wall.

**1** Take deep green and trace around the edge of the character beginning with the foot. Stay on the outside of the color square.

**2** Go from dark to light working with the three shades of green. Add some embellishments as you go. Fade the light green diagonally from left to right to create movement.

**3** Begin the outline starting around the neck and head. Do a fade away like you did with the letters. Take your time and be patient. Remain focused.

**4** Just as you did with the letters, add shadows and fades with black. Walk around the piece and see where you can add these graphic elements to make the character look real and pop off the wall.

**5** Add black along the edge of the color square. Keep the outside edge crisp and blend inward into the deep purple to create an illusion of depth.

**6** Step back and see what you have done. The character is ready. You can now add the final design components for the piece.

Get bonus material at **http://Graff2.impact-books.com**.

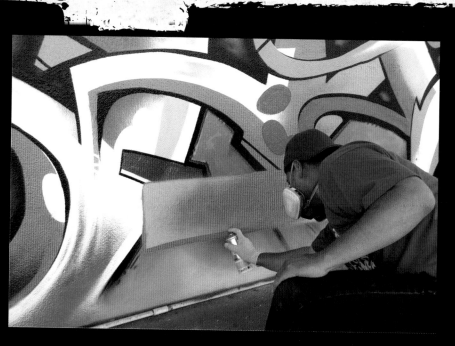

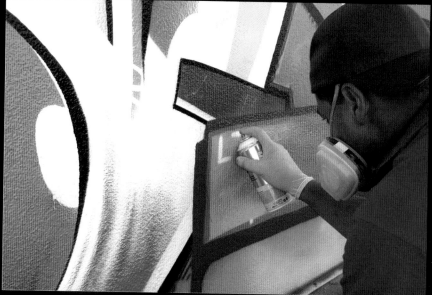

## Step Eleven: Add the Final Elements

Every detail is important. And since you are the artist, only you know where details need to be added and what the final outcome should be. These are your final creative moments. Execute them wisely.

**1** Revisit the middle of the piece and create a tag cloud with pink. Use light pink as an accent, and add a drop shadow and some drips for effect.

**2** Write your quote in white.

**3** Drop in your final quote in the space between the letters and the color square using white and an ultra skinny cap.

Free downloads when you sign up for our newsletter at **IMPACT-books.com**.

119

## Voilá!

Exhale and soak up everything you've accomplished! Take time to study the movement in the piece. Look at the improvisation, where you changed things, maybe went off script. The final product still came out looking great. These are your nuggets of growth, giving new meaning to the word *Awesome*.

**AWESOME**

*Let me take your breath away.*

# WHAT COLOR IS YOUR SOUL?

As graffiti continues to grow, so does its overwhelming influence on the world around us. So where does this influenece come from, what does it consist of, and what do you do when you harness it? I believe it stems from what I call the keep-it-raw sensibility. This characteristic of graffiti art is undiluted and unprocessed, it is so unfiltered that it comes across as raw. This is what attracts the masses to it. This is what allows us to speak to each other on our terms and in our code. It speaks to an incredibly diverse constituency of fans and followers, and empowers those whom society has in many cases forgotten, the voiceless that graffiti art has given a voice to.

Graffiti is a vehicle for honest artwork and sincere statements in an increasingly less than honest world. It is a reflection of truth, even if that truth is simply stating that you exist. People know what is real and sincere when it's placed in front of them, so much so that now authenticity is the benchmark for value. This is why I believe it's important to continually work to expand the possibilities of the art form and keep pushing its boundaries, both aesthetically and philosophically.

So when you are drawing on paper or working on a wall, let yourself create in that moment. Improvise and let yourself respond to everything around you. Let your mind expand and your thoughts flow. Listen to your environment. Listen to the birds chirp, the motorcycles roar by. Listen to the sound of the spray paint, feel the flow of the paint escaping the can. Listen to the twigs underneath your feet, and observe the interaction between the wall and you, between you and the sheets of paper, and yes, your inner feelings. Embrace them.

This book is the end result of months of hard work, patience, dedication and hope. From its inception to its delivery, through all the twists and turns, all of my efforts were focused on trying to articulate the inner workings of the graffiti writer. These efforts became focused on three salient points:

- Educate: To discuss, formalize, categorize and ultimately share the knowledge and hidden meanings of what we call graffiti art, amongst ourselves and its fans, adherents and even detractors.

- Empower: To take our learning and understanding and let it marinate in our being, let it create a sense of cultural urgency, and give a voice to the body's need to create. From information comes transformation.

- Express: With the two previous arrows in your quiver, you can go out and transform your community, your world. Express yourself, and do it with style!

All of this lies within you. It is something that you may not even recognize, or it could be something that you've taken for granted for years. You know it's there. It's up to you to dig into it, to push it and let it come out. When that happens, there is your rocket fuel and the sky's the limit.

You've gotten in touch with your creative style, now it's time to find your creative soul. Is that soul wildstyle, or is it bubble letters? Is it flat, or is it three-dimensional? Do you walk in black and white, or run in full color?

Explore your creative soul and kiss the sky!

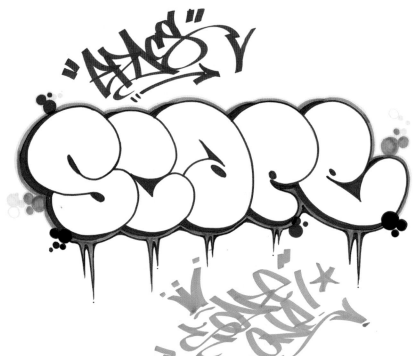

Get bonus material at **http://Graff2.impact-books.com**.

# GLOSSARY

ALL CITY – Can refer to a crew or a writer. Means to go all over the city, in an effort to cover the most with the best.

BACKGROUND – The colors or designs that sit behind the letters. Originally done to discern the letter from the miscellaneous tags and whatever lies beneath the artwork to make it stand out.

BACK IN THE DAY – Means old school or when the writer first started his career.

BACK TO BACK – Graffiti art that is connected from end to end all the way across a wall, or a train, or even a fence.

BATTLE – When two writers or crews go against each other in a challenge to see who is best. It can be a skills battle or a getting up battle, or a mix of both. Sometimes a neutral judge, a group of peers, or an outside crew or writer decides who wins.

BEEF – Disagreement or conflict between two or more people.

BENCH – An area where writers congregate, either to share blackbooks, or to discuss graffiti, i.e., "writers' bench."

BITE – To copy another writer's style, and then claim it as your own. Everyone borrows styles, from all sorts of visual material and from each other, especially when starting out, but few good veteran writers bite.

BLACKBOOK – A graffiti artist sketchbook, sometimes called a "piece book." It is often used to collect other writers' tags, and future plans for bombing, and piecing.

BLOCKBUSTER – Huge block letters, big and square, designed to take up as much space as possible, larger than a throw-up and used many times to cover another writer's work.

BOMB – The action of doing graffiti. Putting up your tag, or doing throw-ups, and/or piecing in a certain area. "Jimmy is bombing that wall."

BUBBLE LETTER – A style of graffiti letters, balloonish and rounded in shape, easily rendered and relatively basic. Used primarily for throw-ups.

BUFF – To remove graffiti from public spaces with chemicals and other materials, or to paint over graff on walls with a flat color.

BURN – To beat any and all competition with your style. Also a descriptive term, as "that piece burns."

BURNER – A full-fledged piece, heavily detailed. Large, full blown, with multiple color fills, background, characters, wildstyle letters, etc.

BURNING – Any graffiti artwork that has not been removed, or covered up, that is still running.

CAPS – The interchangeable spray can nozzles fitted to the can to modify the width of the spray. Caps come both fat and skinny, and countless types in between. Also referred to as "tips."

CHARACTER – An illustrated figure added to a piece to add emphasis or push the idea of the burner forward. Sometimes the character takes the place of a letter in the piece.

CLOUD – A background element used frequently in pieces. Tightly rendered, they can appear as bubbles, or loosely rendered as faded areas of color.

COMPUTER STYLE – A particular type of wildstyle that looks very angular, and has "digital" qualities, or resembles the renderings one would define as being "technological" or "robotic" in nature.

CRAZY – Wild and imaginative. Going to the extreme. "That is a crazy style!"

CREW – A loosely knit band of graffiti writers, a clique. Crews are not gangs, although sometimes confused as such. Many times writers are members of more than one crew at any particular time.

CROSSING OUT – To scribble over or write on top of someone else's name. Considered highly disrespectful.

CUTTING LINES – A painting technique used on characters and the fills of letters to create sharp edges and very thin lines. Thinner than lines made by skinny caps.

CUTTING TIPS – A way to cut standard tips, modifying them to create distorted flair effects.

DEF – Meaning really, really, good. "That style is def!"

DESIGNS – Style elements that go inside your letters on top of your fill-ins. Things such as polka dots, bubbles, stars, swirl patterns.

DIS – Short for the word disrespect. To insult.

DOPE – Another term used to indicate the level of cool. "That is sooo dope."

DOWN – To indicate whom you are connected to or with. To be a part of the group, or OK with the idea. "Oh, we are so down with them." Or, "I'm down with that."

DRIPS – Stylized drips added to a piece or letters to add effects.

END TO END – When a piece covers a surface, whether that is a train, bus or a wall, from one end to the other with no breaks.

FADE – To blend or mix colors.

FADED – To get intoxicated or high. Can also mean that you got disrespected. "Yo, he got faded by homeboy."

FAME – The ultimate prize for a writer. It's what a writer gets when he is consistently getting up. Fame is primarily focused within the graffiti subculture, but many times an artist breaks the mold and gets mainstream recognition.

FAN SPRAY – A stock tip on spray paint cans, which sprays in a fan pattern that can be adjusted. Useless for detailed can control, but great for abstract effects.

**FEMALE TIPS** – A relatively new type of spray can tip. Referred to as a "female" because the can has a "male" counterpart. Traditional cans are the other way around.

**FILL** – Sometimes called "fill-ins." The color patterns inside of the letters of a piece or throw-up.

**FIVE-O** – Slang term for the police.

**FLAT** – Letter style, where the letters appear essentially flat—no 3-D, no shadow, little graphic effects. Essentially straight, legible, one-dimensional letters.

**FLICKS** – Pictures, prints of photos of graffiti.

**FRESH** – Something that is equally new, cool and good.

**FRONT** – As in "to front." To hassle someone, or to want to want to fight someone. Also means when an individual keeps up a mask, or a false exterior. "Oh, he got his front up." Also can mean when someone is trying to impress another with things they can't afford. "Hey, he's trying to front on you with that fake stuff."

**FRONT LETTER** – A letter with a proper face on it where fill-ins can be added. There is a clear distinction between what is and what isn't 3-D. Also called "face letters."

**GALLERY** – Areas that are secluded from the public view, but are popular with graffiti artists. This is an area where the artist's work will stay up for a long time.

**GETTING OVER** – Succeeding at one's designated task.

**GETTING UP** – To hit up a surface, any surface, with any form of graffiti, whether that is a tag or a full-blown burner.

**GOING OVER** – To paint over another's graffiti with your own, with the idea that yours is better. There is a hierarchy of sorts: a throw-up can go over a tag, a piece over a throw-up, and a burner over a piece. It's unacceptable for a throw-up to go over a burner. That is disrespectful.

**GRAPHICS** – Adding extra shading to a character or piece for more realistic three-dimensional effects.

**HAND STYLE** – An artist's handwriting or tagging style.

**HEAD** – As in "graff head," a person who is really into graffiti art.

**HIT UP** – The action of tagging up a surface with paint or inks.

**HITTING UP THE HEAVENS** – Pieces or tags that are done in very hard to reach areas. Because of the nature of the spot, they are especially dangerous to execute and also dangerous to remove. May lead to death if an accidental slip or fall occurs.

**HOMEMADE** – A handcrafted marker made from old deodorant containers or baby food bottles, stuffed with felt chalkboard erasers and filled with permanent ink.

**KILL** – The action of getting up in a major way, to bomb intensely in a certain area.

**KING** – A writer who has mastered the art form. Can also mean the writer who has the best with the most. In some cases a king can be only in certain areas: king of styles, king of throw-ups, king of a certain line.

**LEGALS** – A graffiti piece or a production that is done explicitly with permission.

**MAD** – A quantitative comment, having an obscene amount. "Scape has mad styles."

**MAGNUM** – A very popular type of fat marker.

**MEAN STREAK** – A popular opaque and waterproof paint stick.

**MISCELLANEOUS** – A critical term, when a piece appears to not have balance and symmetry, the letters look "miscellaneous" and slapped together with no forethought.

**MOP** – An oversized type of marker used explicitly for tagging and markmaking. Usually handmade. See HOMEMADE.

**MOTION TAGGING** – Writing on a surface that is in motion, or when you are in motion.

**MURAL** – Large-scale type of piecing, done on a wall. Top to bottom, and end to end. Sometimes called a "production." Encompasses all the elements of a burner, only bigger.

**NEW SCHOOL** – A general term used to refer to the contemporary era of writing. Generally refers to the 80s forward, but it can vary depending on whom you ask.

**NEW YORK FATS** – Old school spray can tip still in wide use. Great all-purpose cap, and great for flair effects.

**NEW YORK SKINNY** – Spray can tips usually borrowed from Krylon Workable Fixatif. Used because of the fantastic line they produced. Opened up a whole new world of can control.

**OLD SCHOOL** – A general term used to refer to an earlier time of writing. Generally refers to the 1970s and 1980s, but can also be a decade reference, meaning a writer in 2007 may refer to the 1990s as old school, and a writer from the 1990s may refer to the 1980s as old school, and so on.

**OUTLINE** – Sometimes called a sketch, the drawing done in a piece book prior to doing an actual piece. Also the final outline done around a piece to complete it.

**PAINT EATER** – An unprimed surface, sometimes wood or concrete, that is very porous and soaks up standard spray paint. Surfaces like these need to be primed.

**PAPERBOY** – A young artist that only does his work on paper, in his blackbook. Has yet to graduate to public surfaces.

**PHANTOM CAPS** – Another term for what are considered New York skinny caps. Usually taken from Krylon Workable Fixatif spray cans.

**PIECE** – Short for "masterpiece," requiring more time than a throw-up. Incorporates 3-D effects, many style elements, color patterns and the like. Characters and symbols are also used.

TO PIECE – The action of going out to paint graffiti, but not tagging.

PIECER – A writer who has abandoned tagging and strictly goes out to piece.

PIECE BOOK – A graffiti writer's sketchbook, where his sketches, outlines, and ideas are kept. Also called a "blackbook."

PRODUCTION – A graffiti masterpiece on a very large scale. Bigger than a burner, usually requiring the talents of multiple graffiti artists over a length of time, whether a few days or a few weeks.

PROPS – Getting respect.

RACK – To steal art supplies.

ROLL CALL – To tag up everyone's name in a particular crew, or writing out the list of artists that helped in creating the piece. Added to the side of the piece.

ROLLER – Large piece done with a paint roller as opposed to spray paint.

ROLLERS – Slang term for the police. "Here come the rollers!"

RUN – The length of time a graffiti piece remains up before being removed.

SCRIBER – A tagging instrument, made from drillbits, sharp metal, or found objects. Used to physically engrave one's name onto a surface. Considered by many to have little artistic merit and is purely mass destruction.

SCRUB – A writer who is simply not that good. Not to be confused with a "toy," which is a beginner. A scrub has been at it for a while and is still not very skilled.

SICK – Very, very good, both at technique and style. "Johnny has sick style."

SIDEBUSTING – To paint your name right next to someone else who was there first.

SILVERS – A piece or a throw-up with only silver for a fill-in.

SLASH – To put a tag, or a blemish, a line, a mark out, over someone's piece. Considered a form of disrespect.

STENCIL TIPS – Shell type of attachment that goes over the cap area of a spray can. It has a tiny hole cut into it, and is used to create needle-thin spray paint lines. The old school method was to handmake them. Today they can be bought in a store.

STICKERS – Considered a form of tagging. Most commonly saying, "Hello my name is," but can be any type of illustration placed on a sticker and plastered all over the public sphere.

STRAIGHTS – Straight-edged, blocky, and easy-to-read graffiti letters. A very simple style.

TAG – A writer's signature, his "nom de plume." For example, "Scape" is my tag. The most basic form of graffiti, it is essentially the writer's logo. Can also be the action of signing your name, as in "to tag."

TAGGER – Also called "tagbangers," a combination of the words "tagger" and "gangbanger." They only tag but never piece. Not considered true writers or artists by other graff writers and are mostly considered a hindrance and a negative influence.

TAGGING UP – The act of writing your "tag" or signature on a surface.

3-D – An added dimension of style, a three-dimensional style added for a realistic effect to letters.

THROW-UP – Your name in quickly drawn bubble letters with one or two colors and an outline. Done VERY quickly. Used to cover space, grab attention, and show that you were there.

THROWIE – Contemporary term for a throw up.

TOP TO BOTTOM – Originally meaning a piece that covered a train car from the top to the bottom. These days it can also pertain to a wall or a building, many times becoming synonymous with a "mural."

TOY – When a writer first starts out he is considered a toy. But as a writer continues his path it becomes a derogatory term for an unskilled or weak artist.

ULTRA WIDE – Any marker that is about an inch and a half in width. It is also is refillable.

UP – When a writer is very active and has work appear regularly in many areas.

VIRGIN – A pristine untouched white wall. "That wall is virgin." Also, a young writer who has yet to paint on a wall with spray paint.

WACK – Refers to an ugly style, when something is substandard or looks weak.

WEAK – A style or artist that doesn't stand out. Lacking boldness in his efforts. See WACK.

WHITE WASH – To cover a tagged wall with a layer of house paint in order to prep it for your work.

WHOLE CAR – A collaborative effort where a whole train car is covered from top to bottom and end to end.

WHOLE TRAIN – Like a whole car, but covering an entire train. A collaborative effort.

WILDSTYLE – An elevated style of letters, with lots of arrows, connections, and complex color patterns. Difficult to master, and entirely unreadable.

WRITER – Someone who practices the art of graffiti.

Free downloads when you sign up for our newsletter at IMPACT-books.com.

125

# INDEX

Other fine IMPACT Books are available from your local bookstore, art supply store or online supplier. Visit our website at www.fwmedia.com.

15   14   13   12   11      5   4   3   2   1

DISTRIBUTED IN CANADA BY FRASER DIRECT
100 Armstrong Avenue
Georgetown, ON, Canada  L7G 5S4
Tel:  (905) 877-4411

DISTRIBUTED IN THE U.K. AND EUROPE BY
F+W MEDIA INTERNATIONAL
Brunel House, Newton Abbot, Devon, TQ12 4PU, England
Tel: (+44) 1626 323200, Fax: (+44) 1626 323319
Email: postmaster@davidandcharles.co.uk

DISTRIBUTED IN AUSTRALIA BY CAPRICORN LINK
P.O. Box 704, S. Windsor NSW, 2756 Australia
Tel: (02) 4577-3555

**Library of Congress Cataloging in Publication Data**

Martinez, Scape
  Graff 2 : deeper elements of graffiti style / Scape Martinez.
-- 1st ed.
      p. cm.
  Includes index.
  ISBN 978-1-4403-0827-7 (alk. paper)
  1.  Mural painting and decoration--Technique. 2.  Graffiti--Technique.  I. Title. II. Title: Graff two. III. Title: Deeper elements of graffiti style.
  ND2550.M375 2011
  751.7′3--dc22
                              2010045123

Edited by Christina Richards and Kelly Messerly
Designed by Guy Kelly
Production coordinated by Mark Griffin

**Photographer: Patricia Carolina Ruiz**

## ABOUT THE AUTHOR

Born in Newark, New Jersey, and now living in San Jose, California, Scape Martinez has been creating art since childhood. When in his early teens, he fell in love with graffiti art.  He authored the bestselling *GRAFF: The Art & Technique of Graffiti*, detailing the styles and techniques of the often misunderstood artform.

Scape has a remarkable gift for illustrating and articulating abstract thoughts and issues, and he frequently gives educational lectures on creativity and graffiti art's place in society.

He has done public art projects for the city of San Jose, created murals for various schools and universities, and frequently shows his artwork in various galleries and settings. Scape continues to push the boundaries of graffiti art as well as his own unique form of artistic expression. You can visit his website at www.scapemartinez.com.

## ACKNOWLEDGMENTS

There are a number of wonderful people who contributed in innumerable ways to my experiences in creating this book. Thank you to everyone at IMPACT. My gratitude to Pam Wissman, Mona Michael, Kelly Messerly and Christina Richards—you have all generously shared your expertise to push this project forward.

Rosie Lopez, thank you for all the prayers, compassion, encouragement and enthusiasm that I received while working on this project.

## METRIC CONVERSION CHART

| To convert | to | multiply by |
| --- | --- | --- |
| Inches | Centimeters | 2.54 |
| Centimeters | Inches | 0.4 |
| Feet | Centimeters | 30.5 |
| Centimeters | Feet | 0.03 |
| Yards | Meters | 0.9 |
| Meters | Yards | 1.1 |

# IDEAS. INSTRUCTION. INSPIRATION.

These and other fine IMPACT products are available at your local art & craft retailer, bookstore or online supplier or visit our website at **www.impact-books.com**.

**Special Effects for Digital Coloring with Brian Miller**
DVD running time: 50 minutes

**Digital Dragons**
DVD running time: 64 minutes

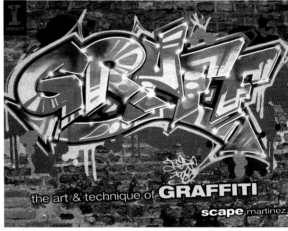

**Graff**
paperback • 128 pages

# IMPACT-BOOKS.COM

- Connect with other artists
- Get the latest in comic, fantasy, and sci-fi art
- Special deals on your favorite artists

Visit **www.artistsnetwork.com**, sign up for our FREE e-newsletter, and receive a free gift.